A STAINED GLASS JOURNEY

out and about
with
JILLIAN SAWYER

Photography
CHRIS GARNETT

Published by
GLASS BOOKS PTY LTD

Printed in Western Australia

This book is dedicated to Olive and Jack Sawyer, my very much loved other mum and dad.

For their very kind co-operation in the photography of their homes and businesses, our very sincere thanks to:

Mr M Jardine
Mr and Mrs Masiello
Mr and Mrs Forden
Mr and Mrs Palmer
Mr G Archer CGX Pty Ltd
Tumblegum Farm Reception Centre
Mr and Mrs Gosling The Witch's Cauldron
Mr J Quinn Harlequin Horse Antiques
Mr and Mrs McOnie Cafe Ivey
Mr and Mrs Kellie
Mr and Mrs Lombardi
Mr and Mrs Cossill
Mr and Mrs Birrell

The National Library of Australia Cataloguing-in-Publication entry

Sawyer, Jillian.
A stained glass journey: out and about with Jillian Sawyer.

ISBN 0 9585282 4 1.

1. Glass craft - Patterns. 2. Glass painting and staining - Patterns. 3. Decoration and ornament, Architectural - Australia - Pictorial works.
4. Glass painting and staining - Australia - Pictorial works. I. Garnett, Chris. II. Title.

748.5

Published by Glass Books Pty Ltd
PO Box 891 Subiaco Western Australia 6904
sales@glassbooks.com.au
www.glassbooks.com.au

June 1996
Reprinted October 1997
Reprinted December 1999
Reprinted August 2002
Reprinted March 2003

Foreword

This book is a journey through the years during which Brian and I have been involved in stained glass. At career beginnings you are influenced by others' work in the field. Then gradually you develop your own style. When we stand back and take stock, we are amazed at the variety of style, design and the concepts that have evolved from those early years.

The diversity of peoples lives, ideas, visions and influences is enormous and the lasting impact some of these personalities have had on our lives, be they clientele, student, family or fellow workers, is part and parcel of this journey:

To our peers, who have remained our friends from the formative years.

To our students, who years later still visit us and produce amazing work.

To our families, who love and support us always.

To our clients, whose challenges grace the pages of this book.

And to those strange, sometimes fleeting, sometimes lasting contacts and happenings that somehow send you barrelling in a new direction.

Brian and I thank you. We value you. You have enriched our journey.

JILLIAN SAWYER

PO Box 522
Cannington
Western Australia 6107
Email: firebird@iinet.net.au

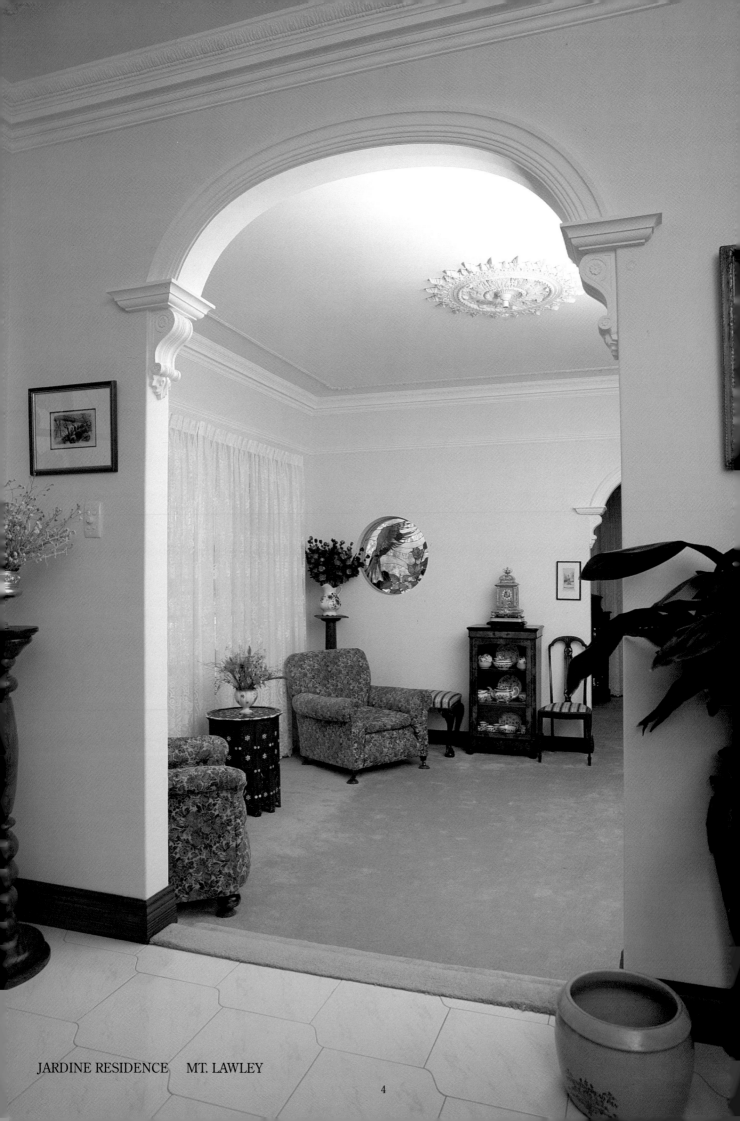

JARDINE RESIDENCE MT. LAWLEY

4

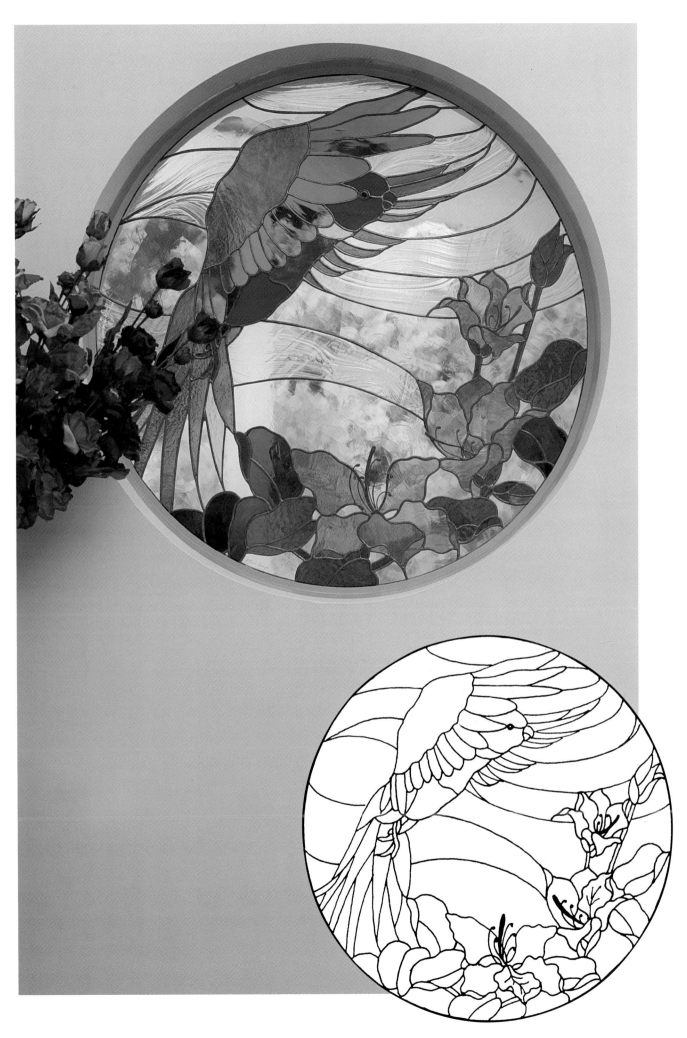

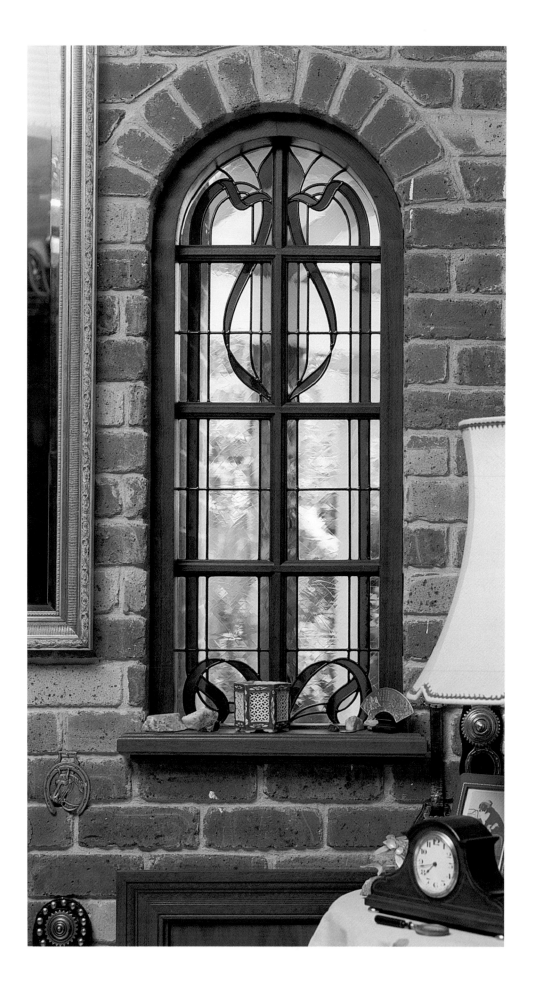

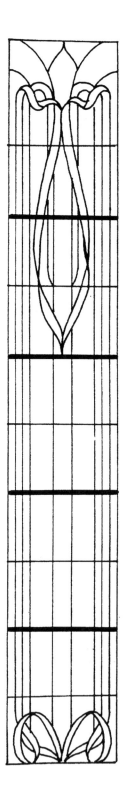

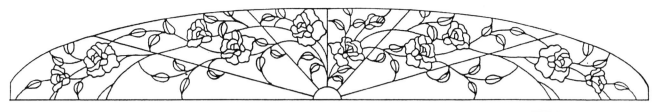

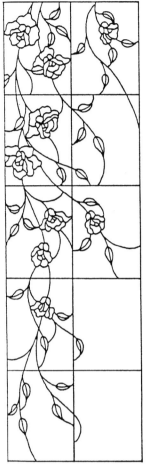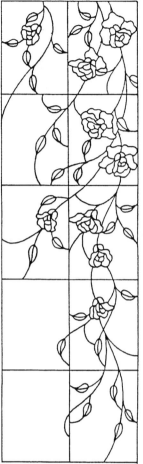

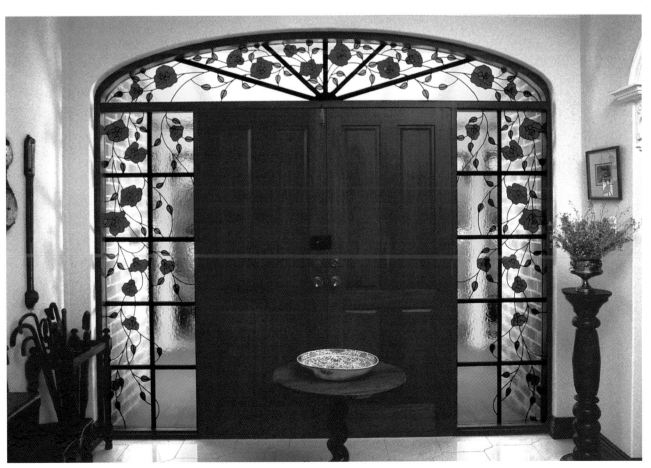

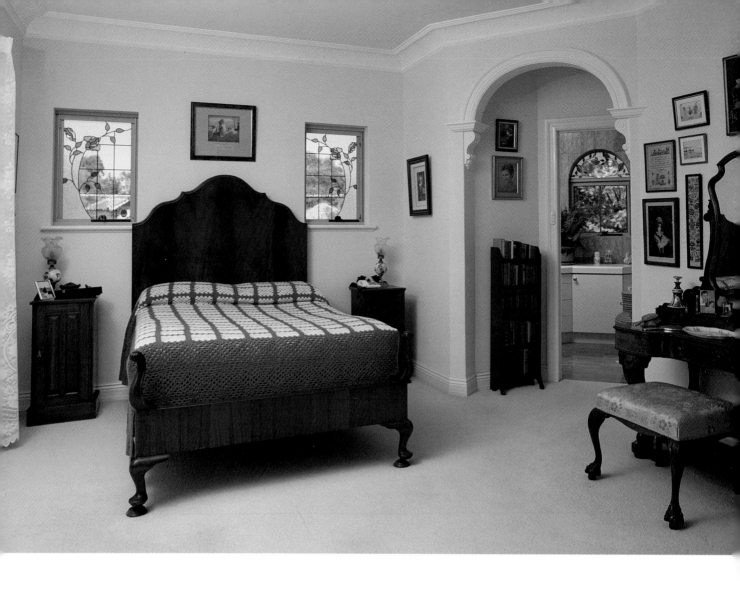

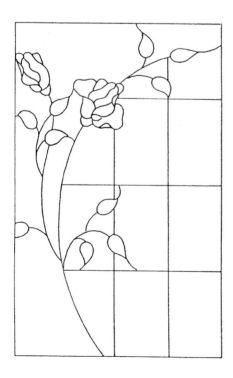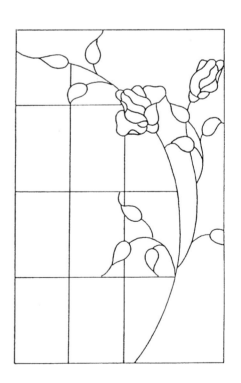

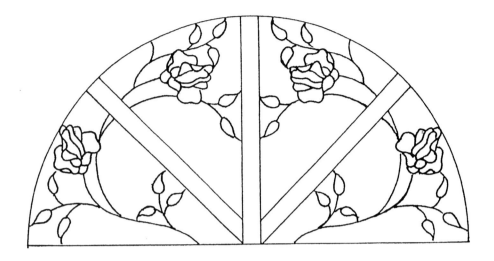

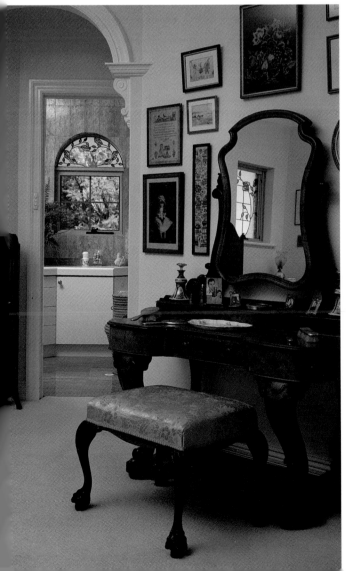

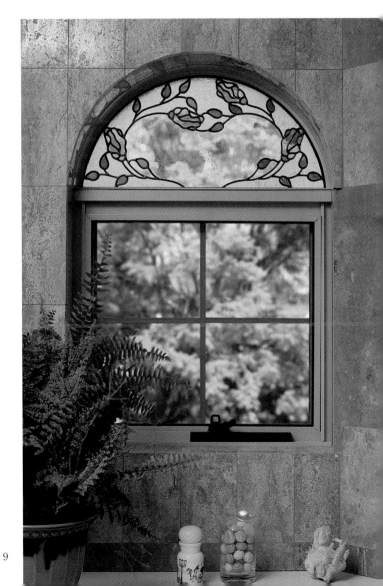

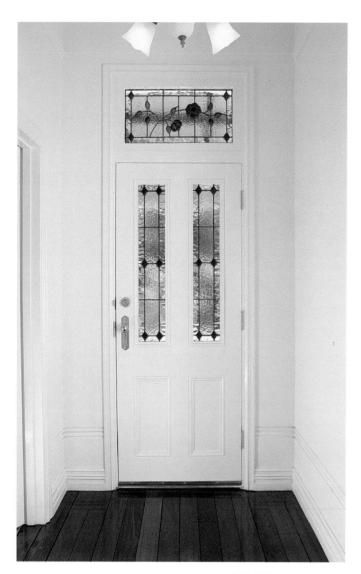 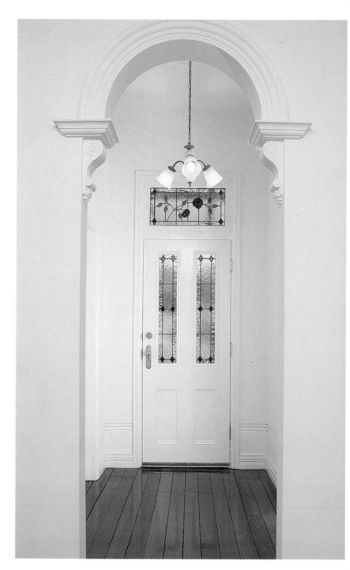

MASIELLO RESIDENCE VICTORIA PARK

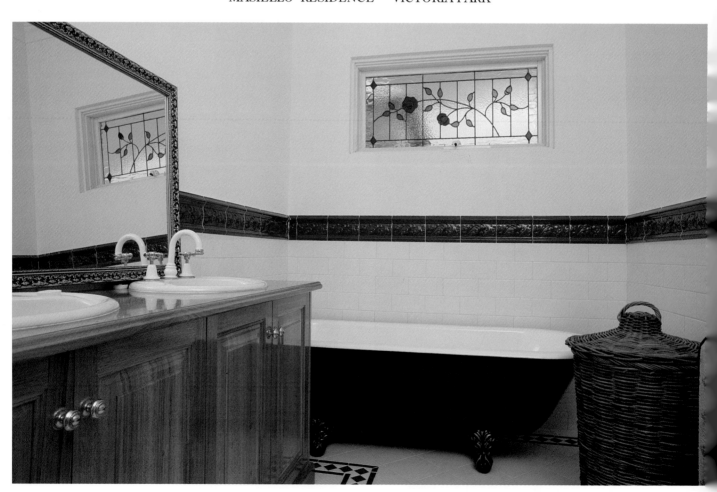

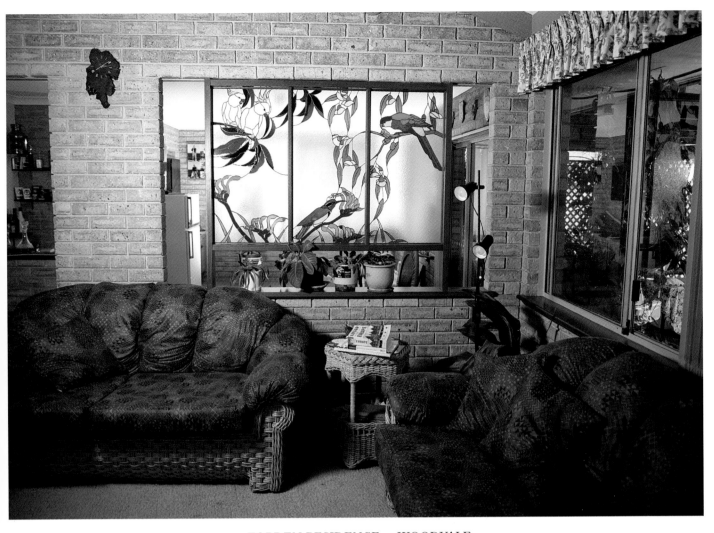

FORDEN RESIDENCE WOODVALE

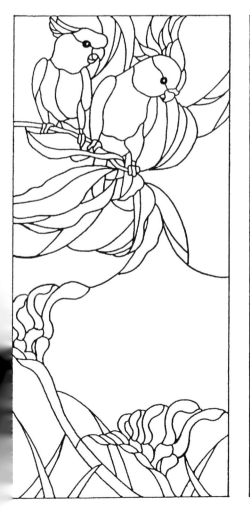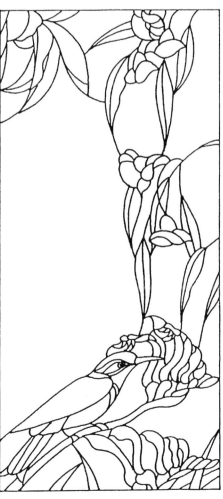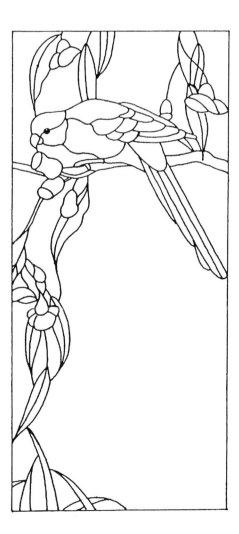

11

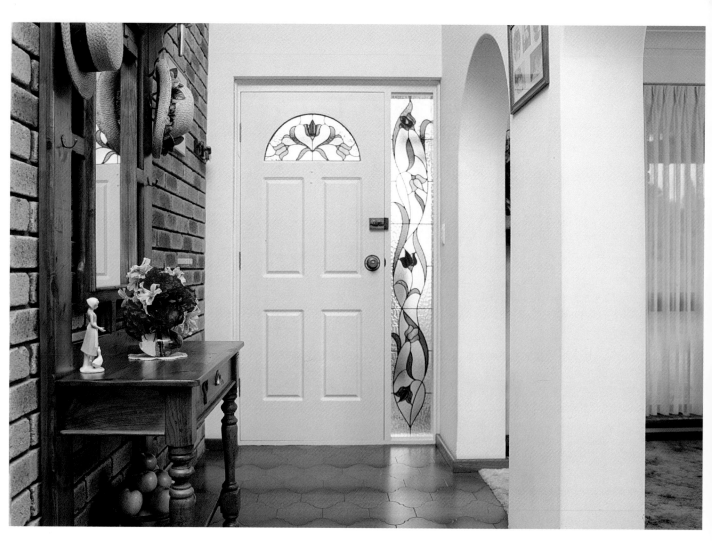

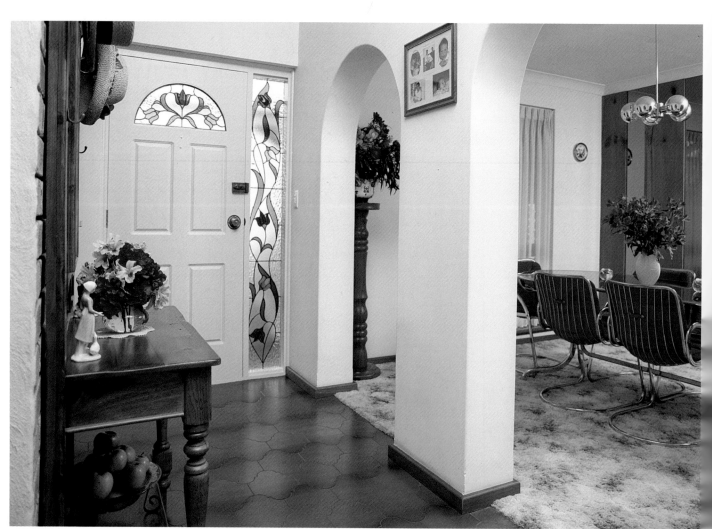

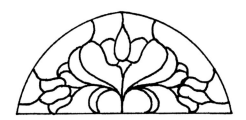

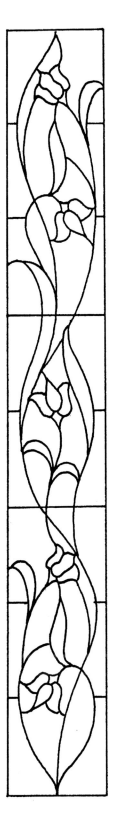

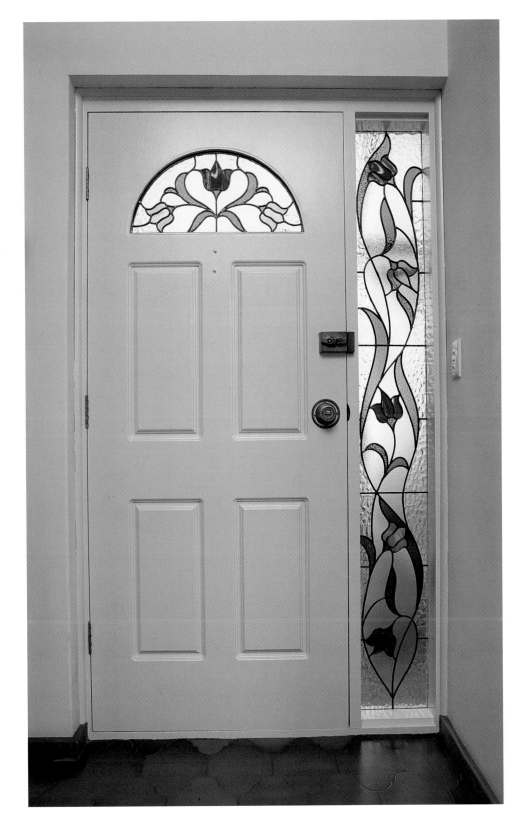

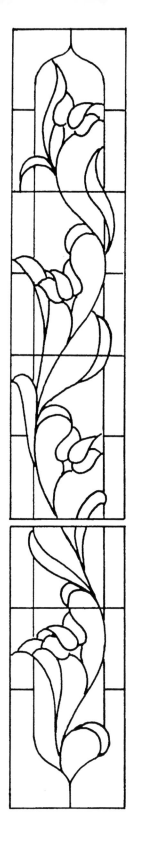

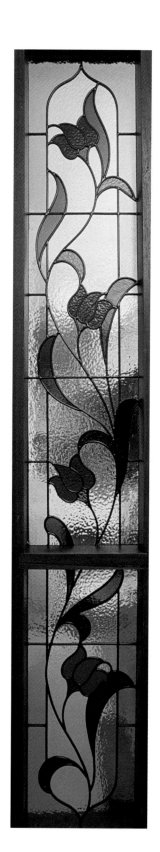

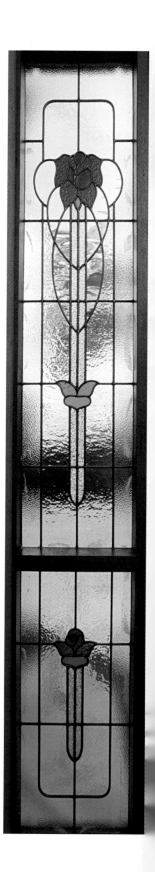

ARCHER UNITS VICTORIA PARK

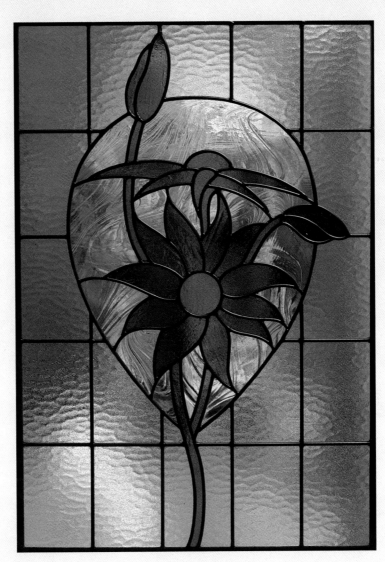

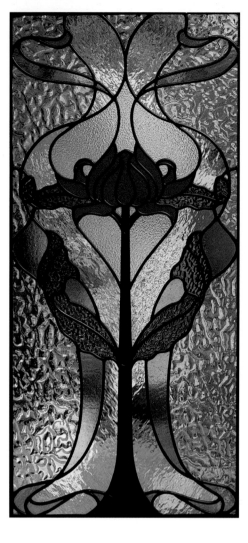

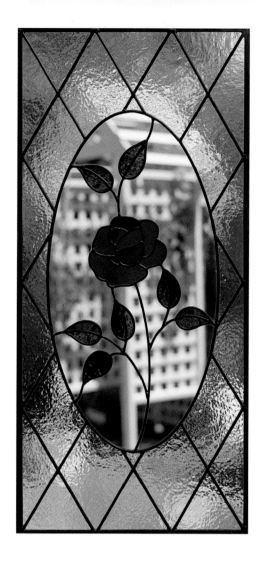

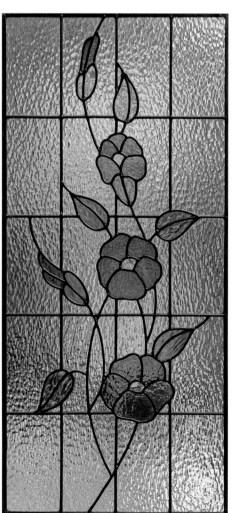

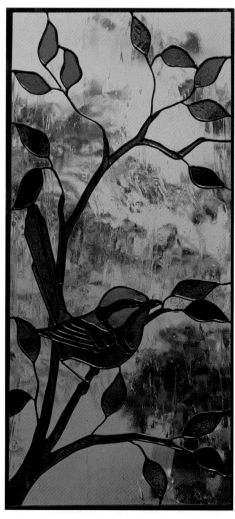

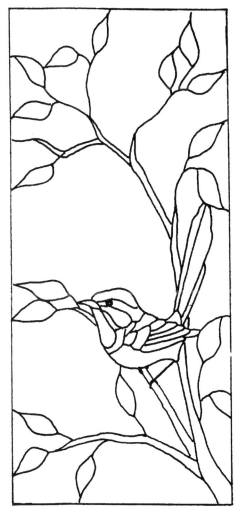

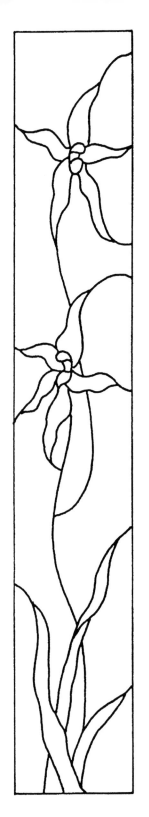

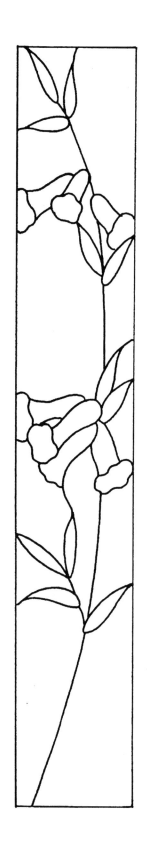

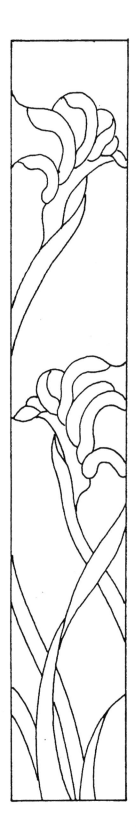

WILDFLOWERS

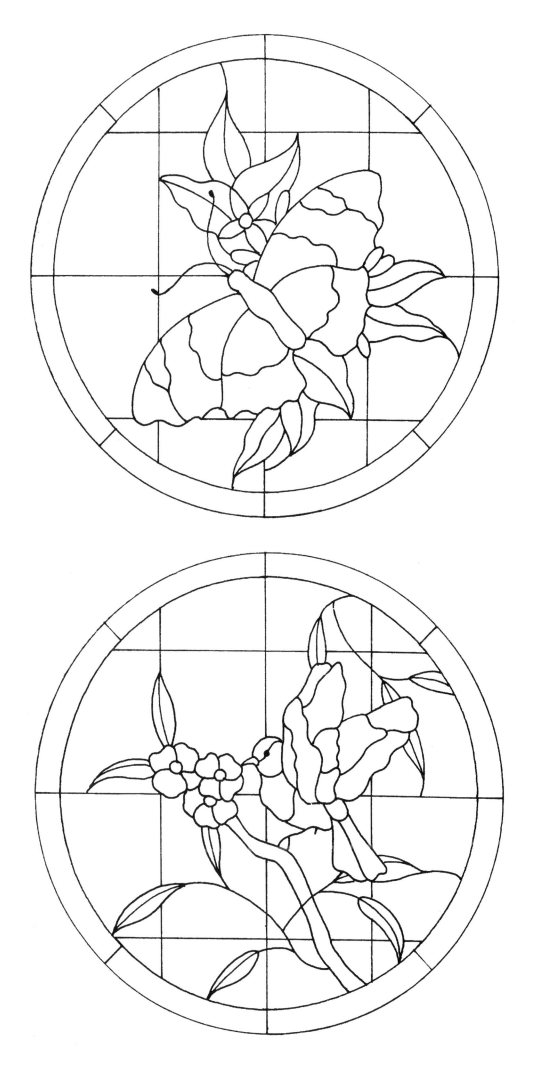

19

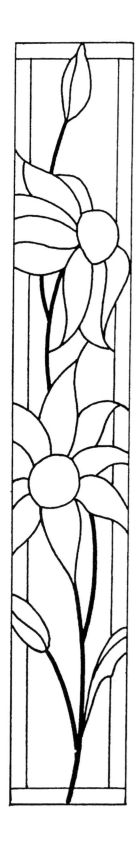

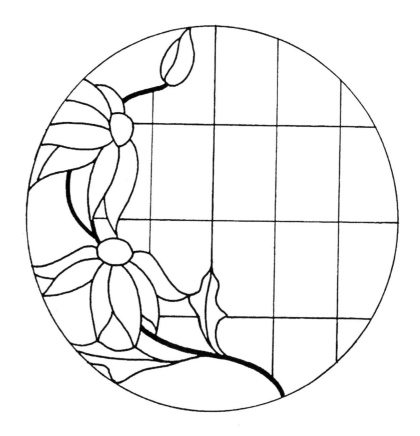

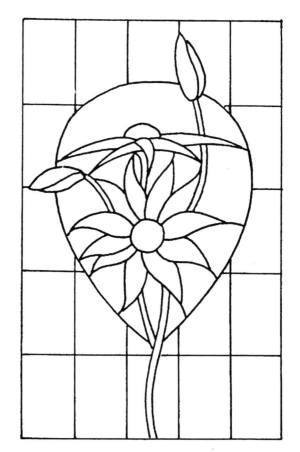

Colour photograph page 16

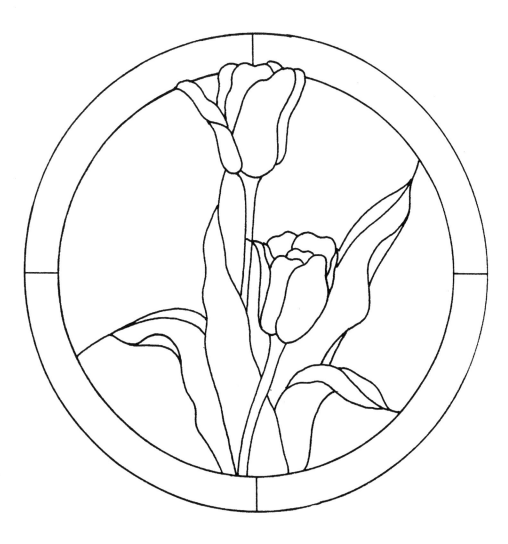

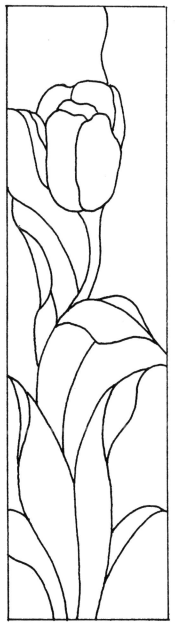

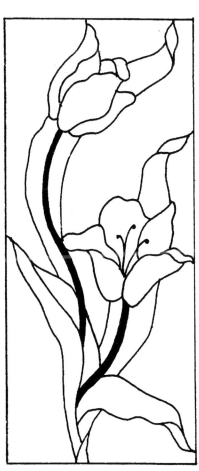

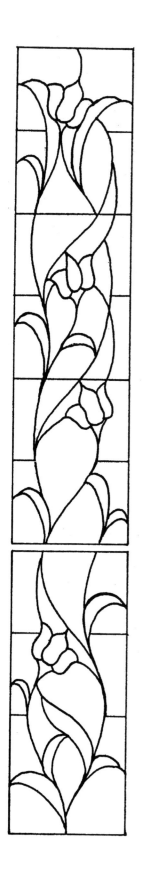

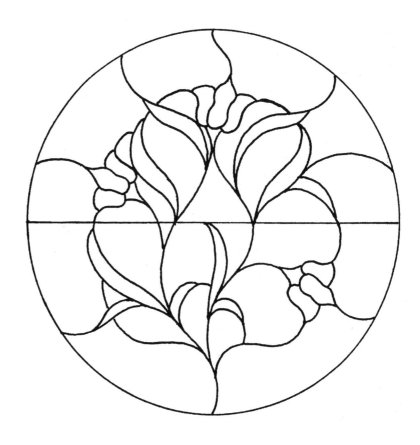

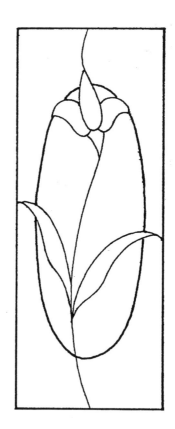

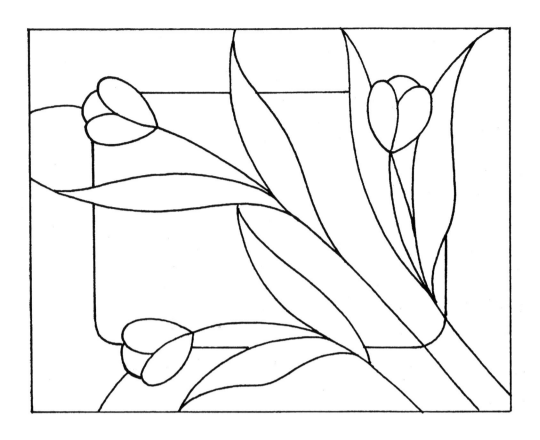

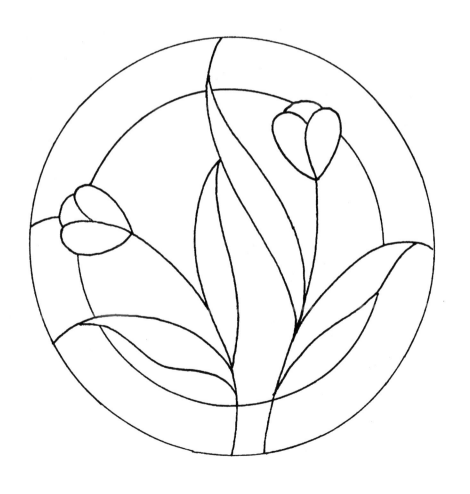

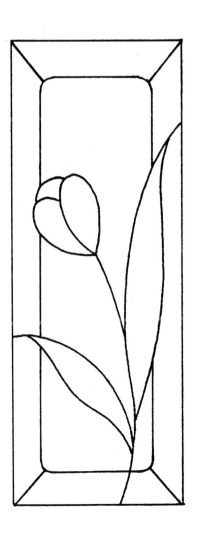

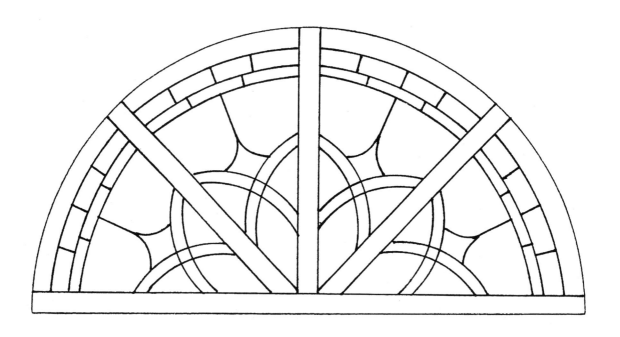

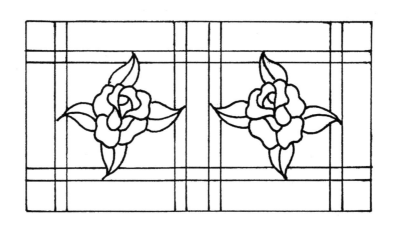

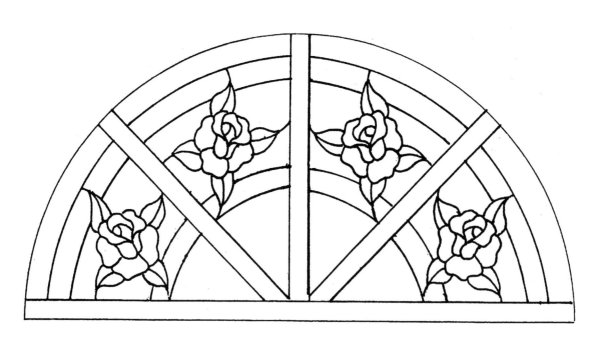

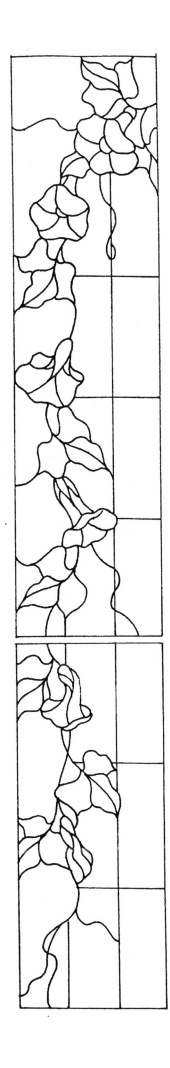

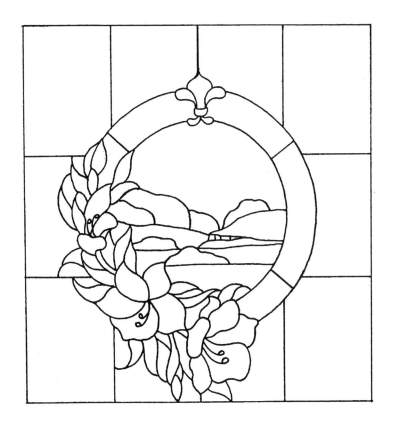

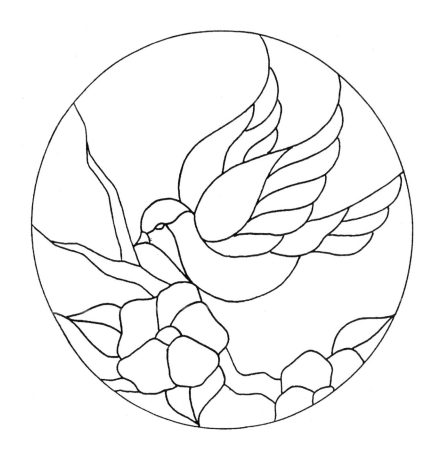

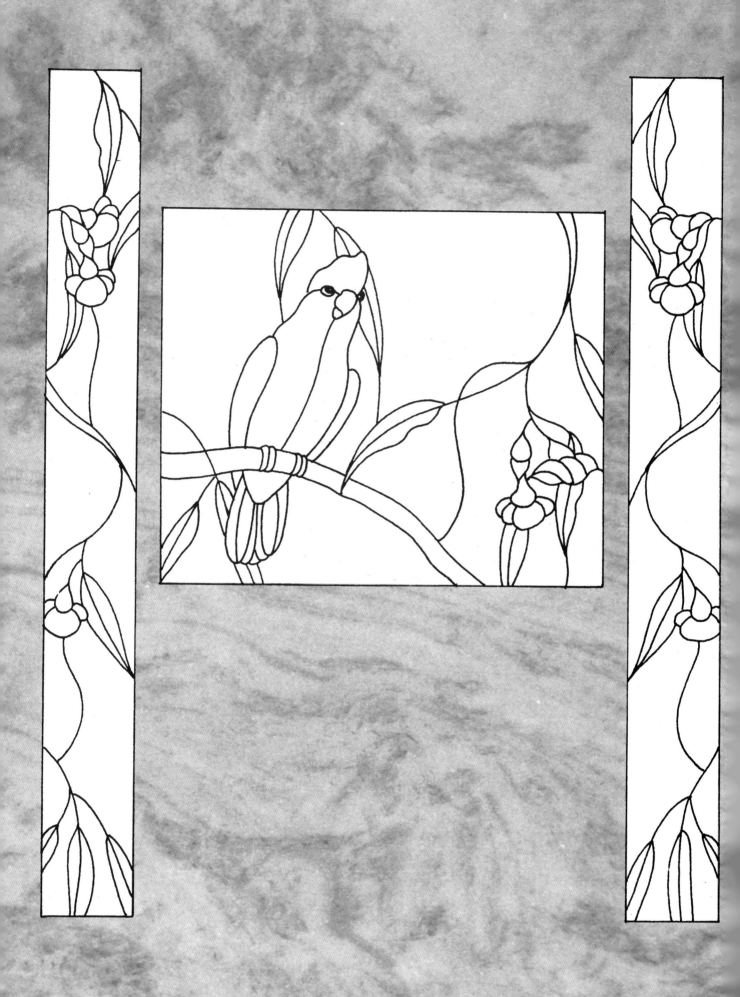

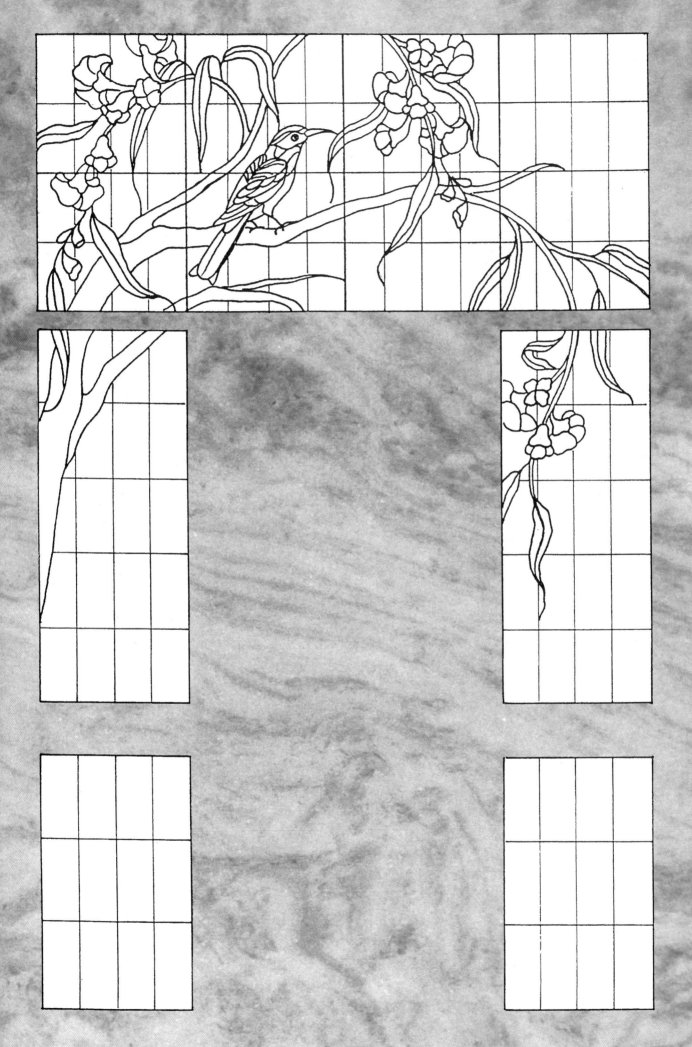

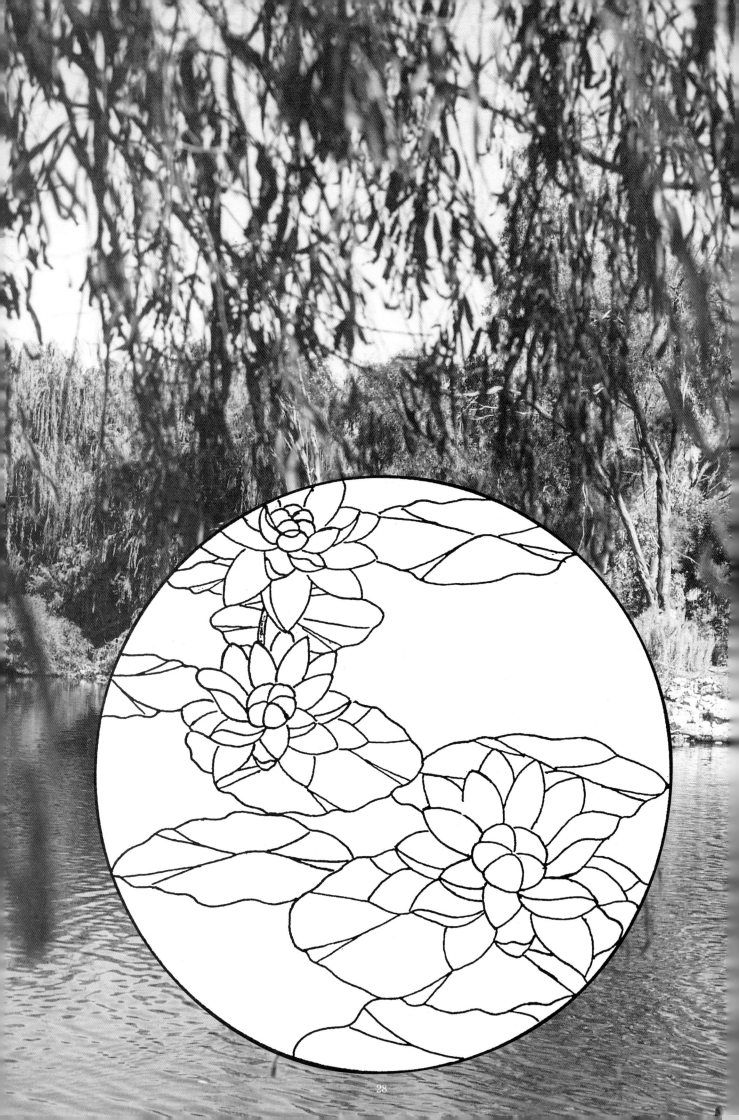

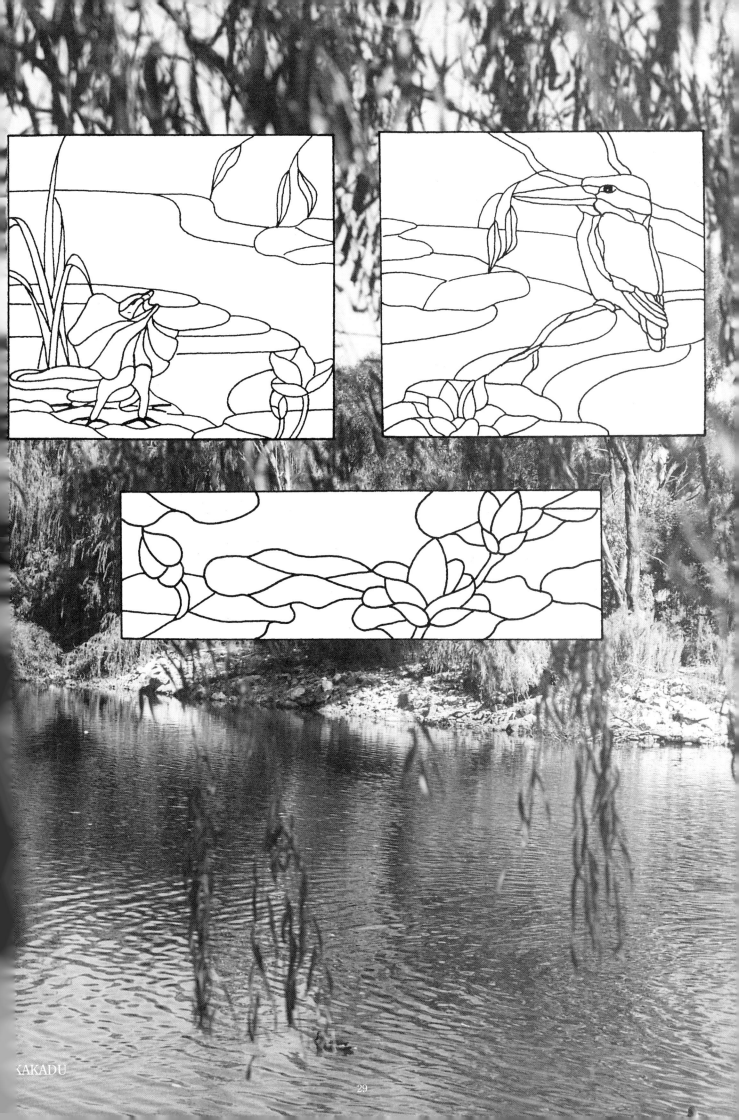

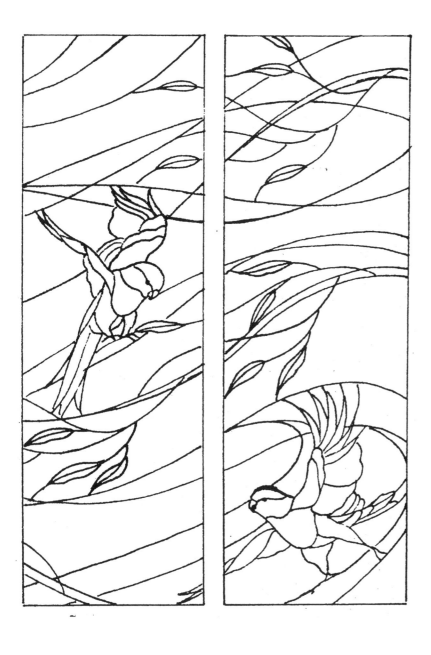

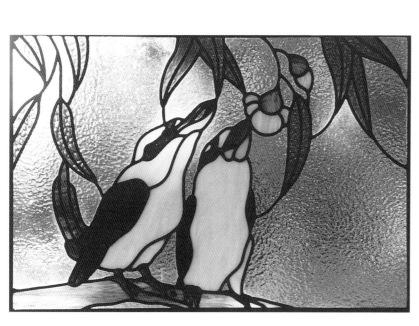

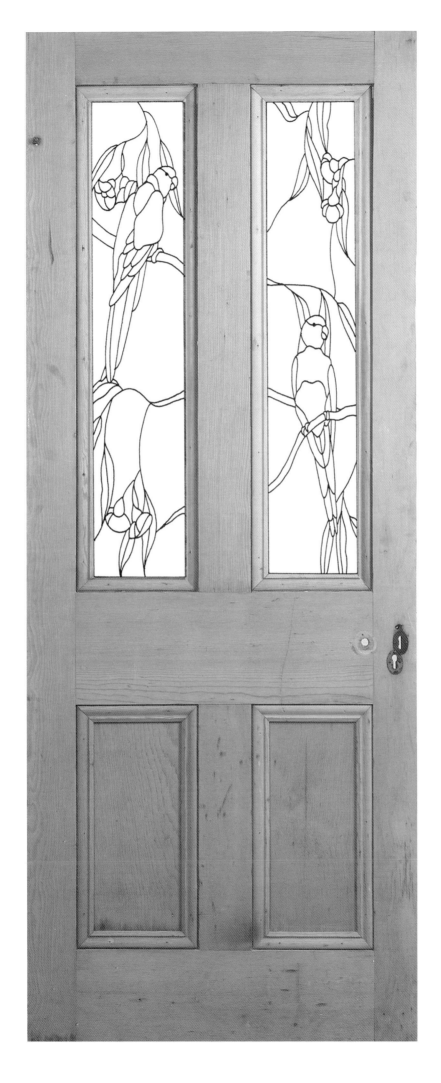

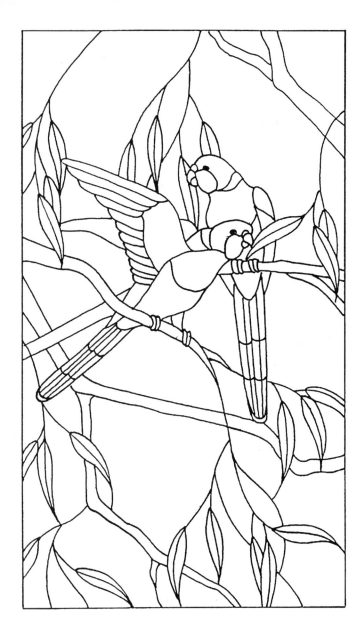

TUMBLEGUM FARM
RECEPTION CENTRE BYFORD

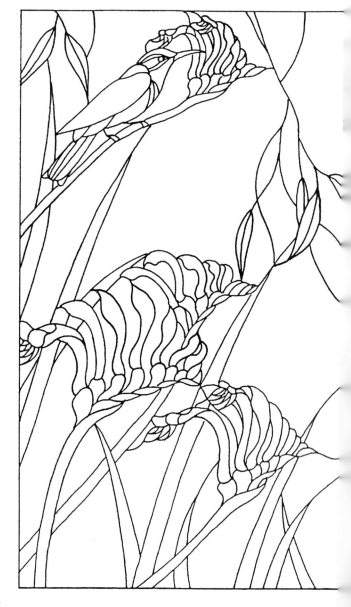

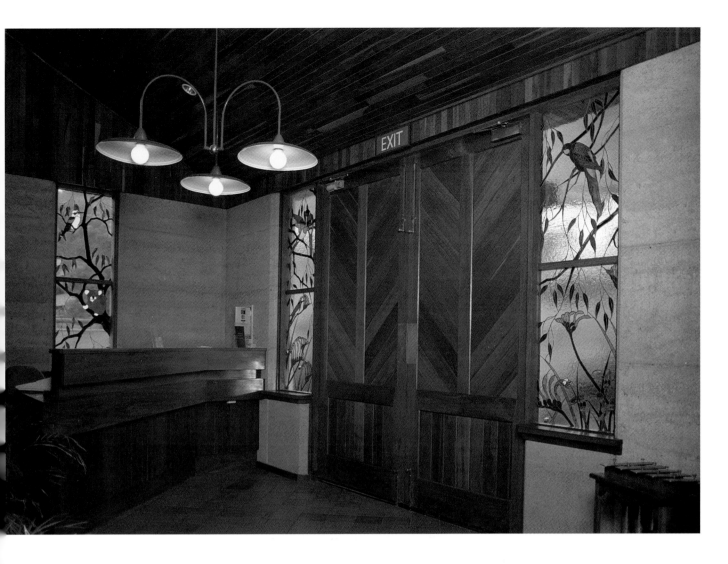

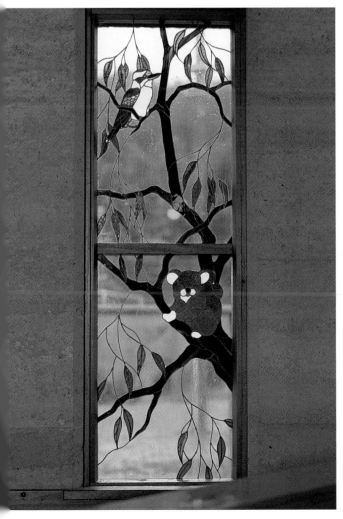

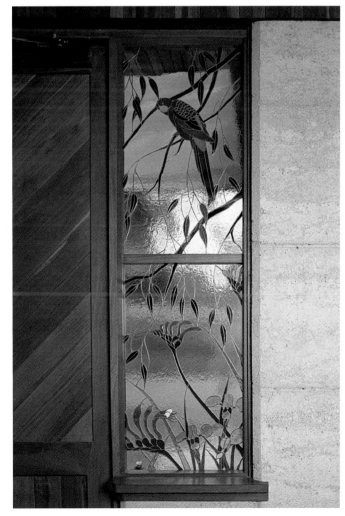

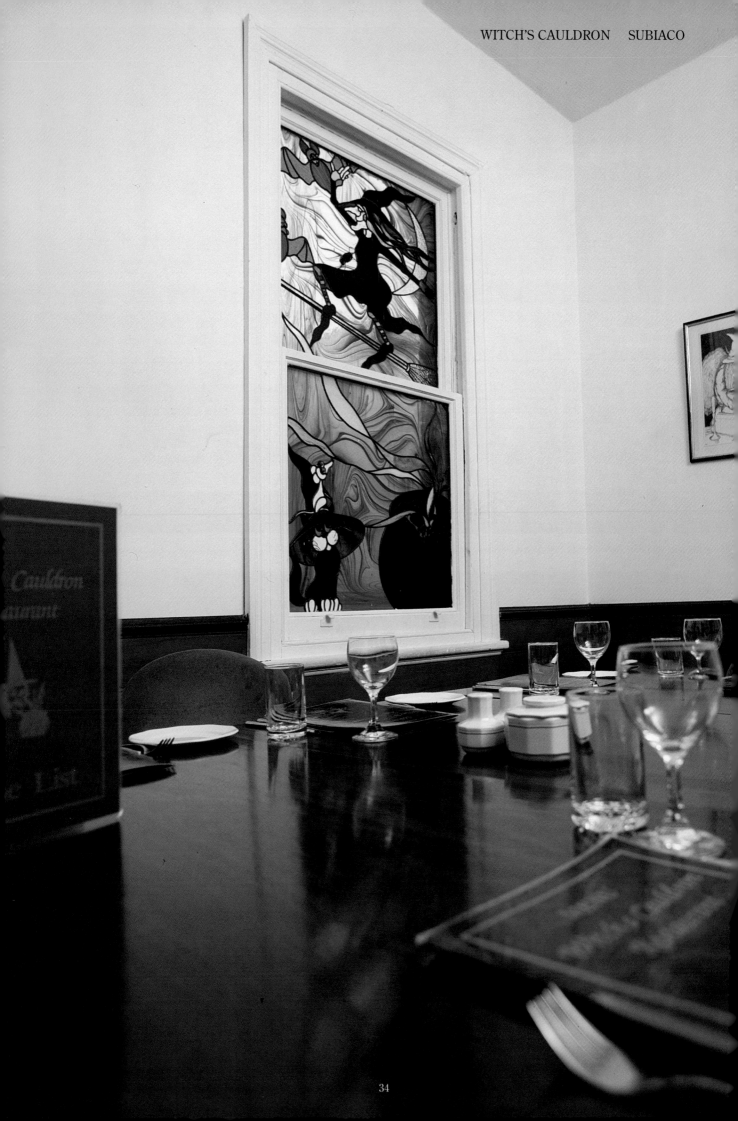

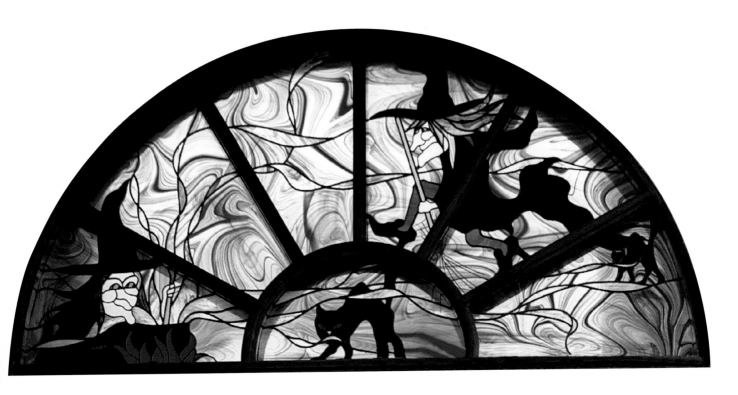

The Witch's Cauldron restaurant in Perth, Western Australia has long been famous for its delicious garlic prawns. In more recent times it's feature stained glass has also become renowned and restaurant patrons now enjoy their meal in the company of these delightfully wicked ladies.

The *Cauldron* is one of several successful collaborations over the years between Jillian Sawyer and Wayne McOnie (Cafe Ivey in Kings Park, featured page 37 is another). It has certainly been one of the most enjoyable, with mine hosts Geoff and Tanis Gosling allowing free rein.

This project is possibly not over yet, with Geoff and Tanis always finding nooks and crannies to fit yet another witch!

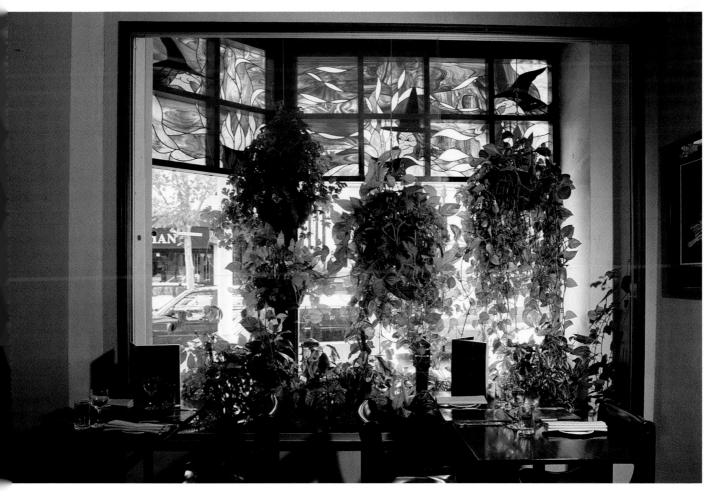

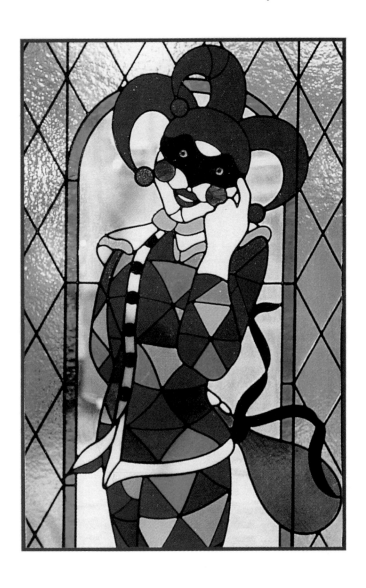

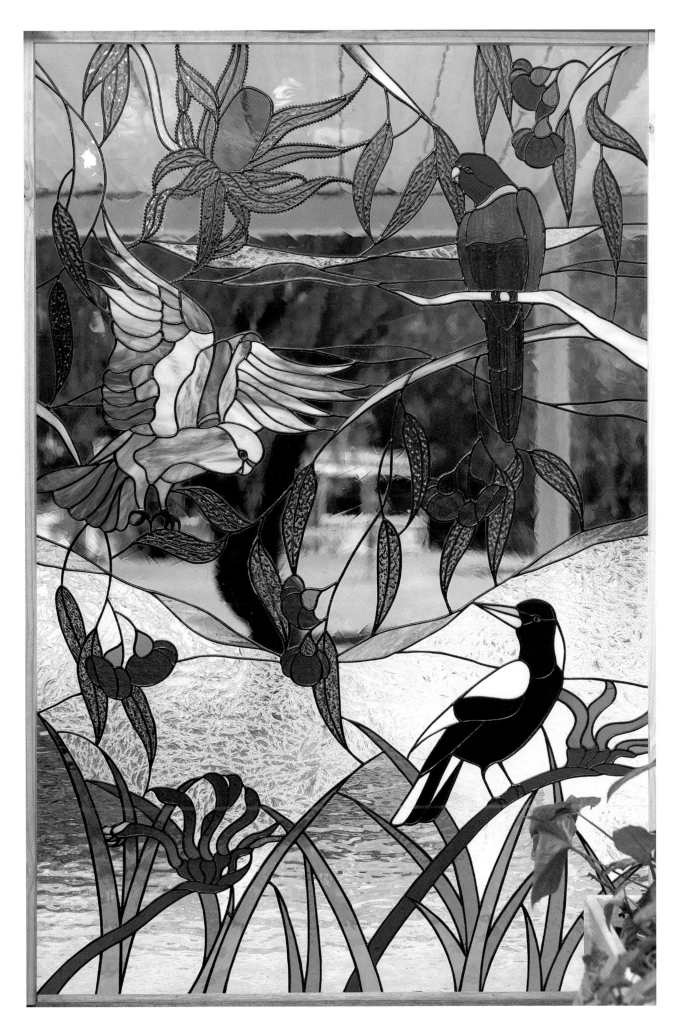

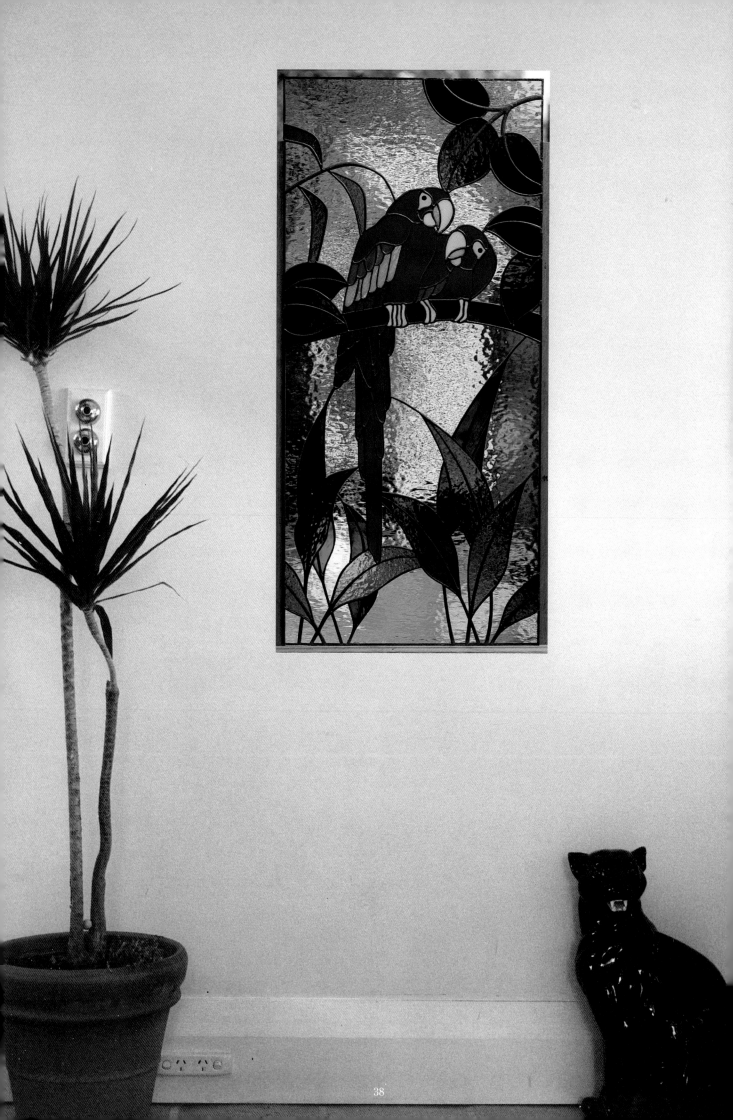

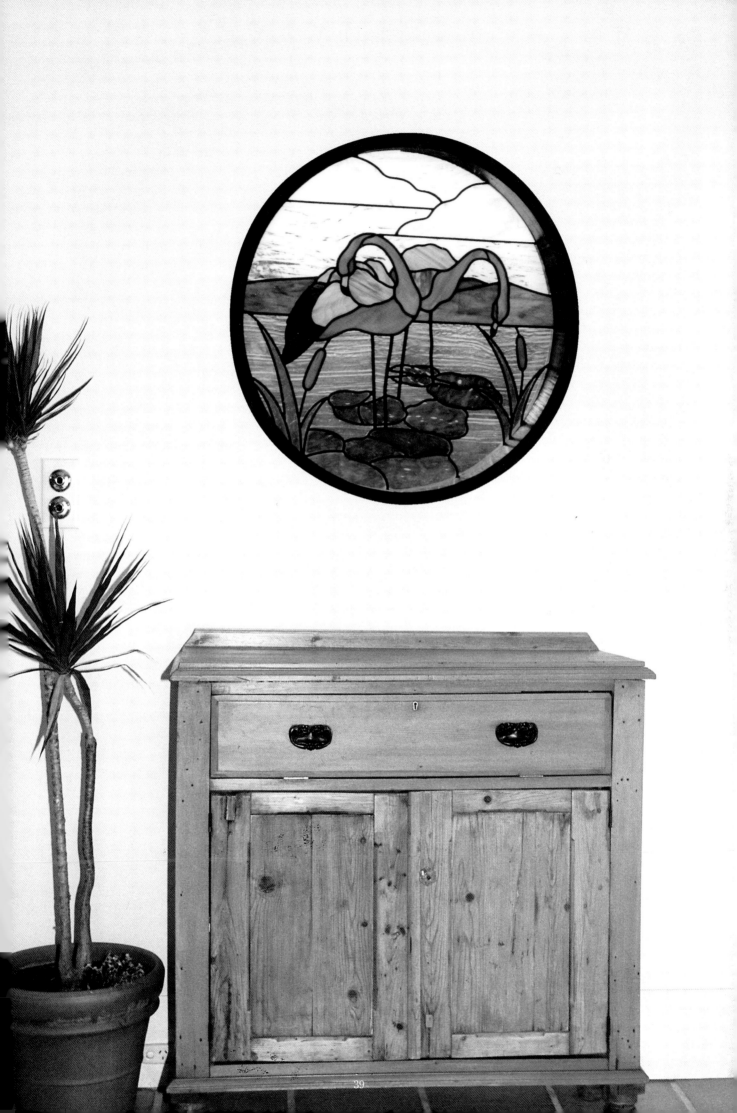

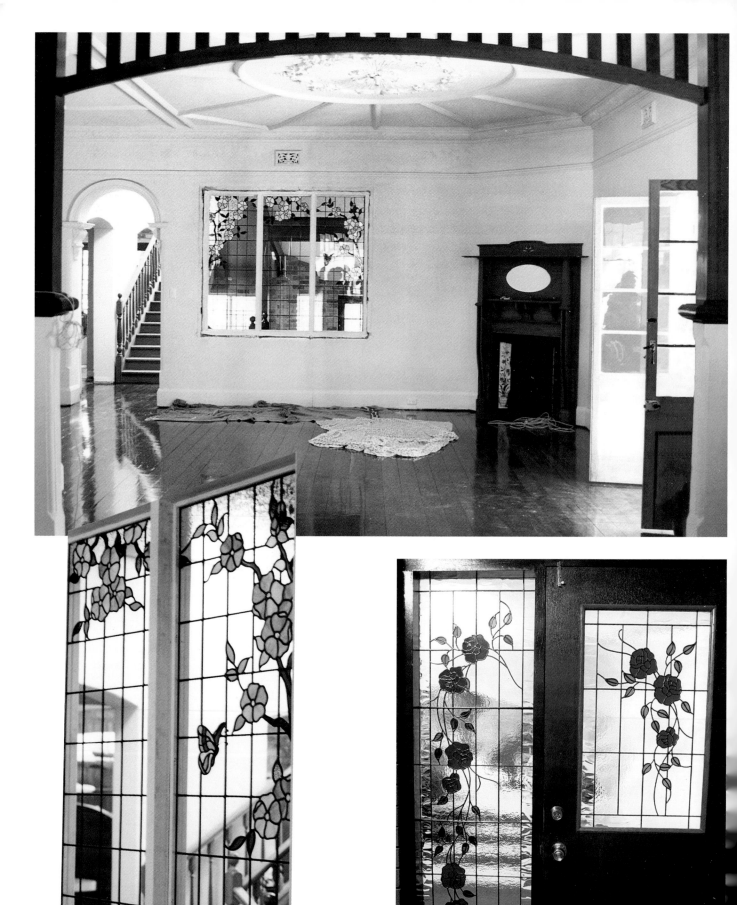

KELLIE RESIDENCE MAIDAVALE

Kellie design
adapted for sliding
window

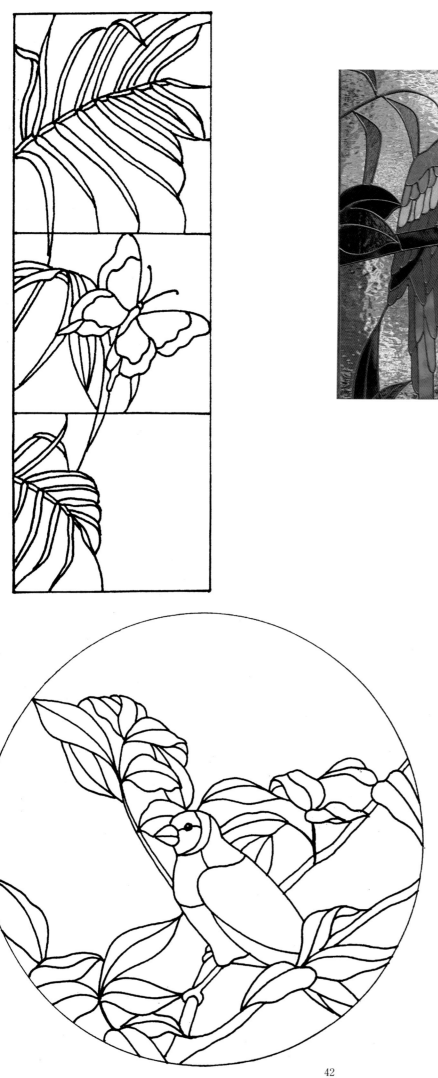

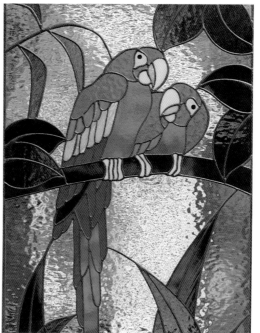

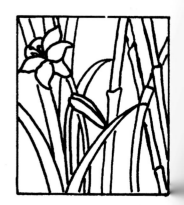

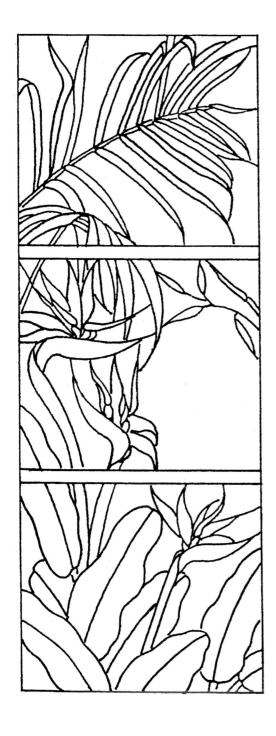

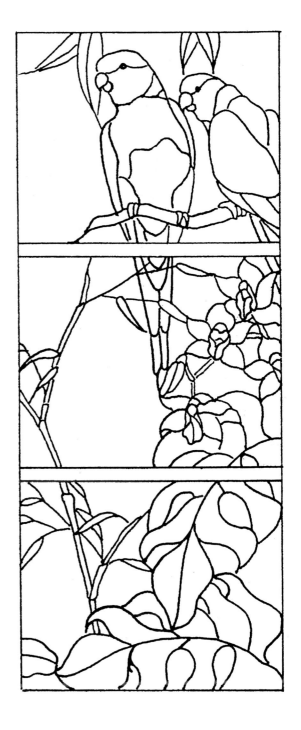

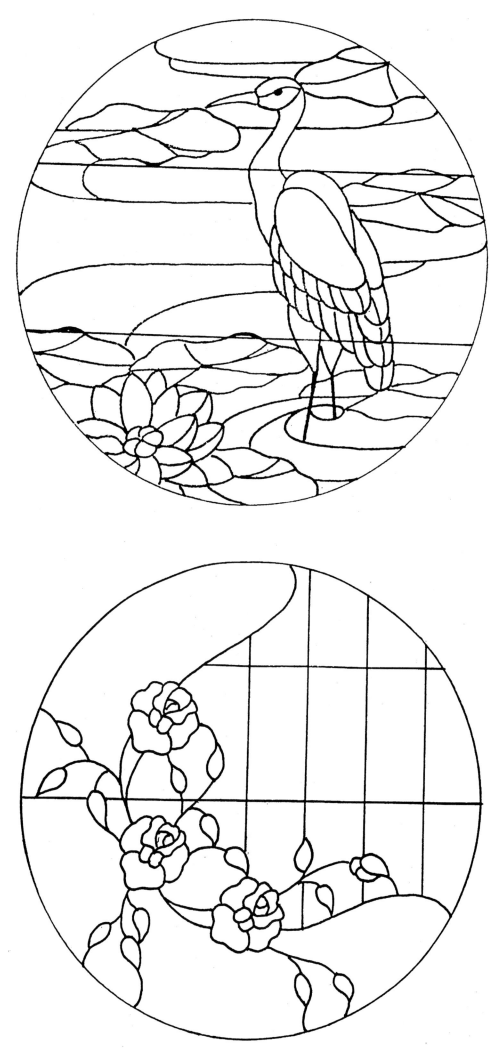

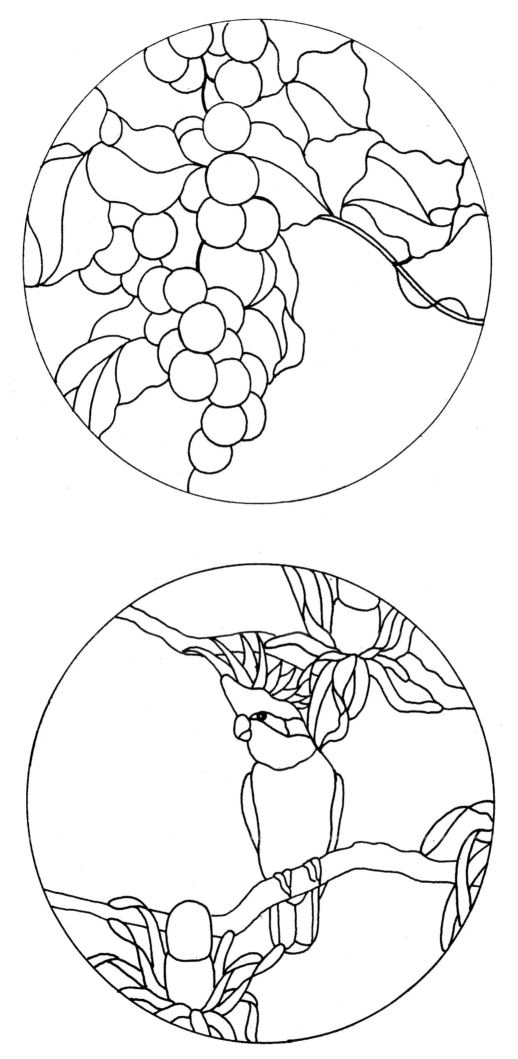

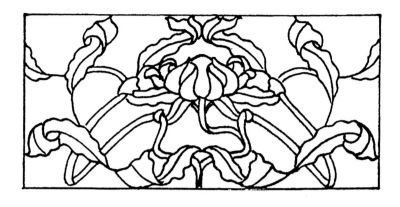

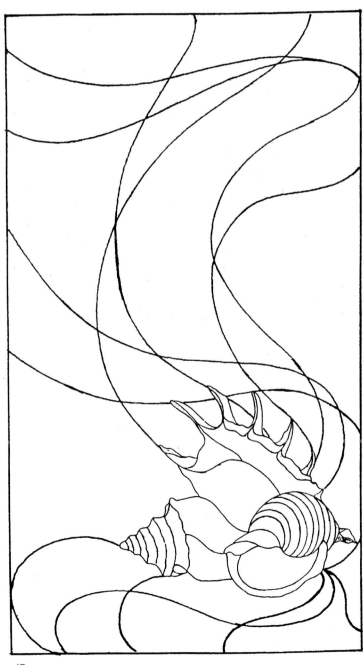

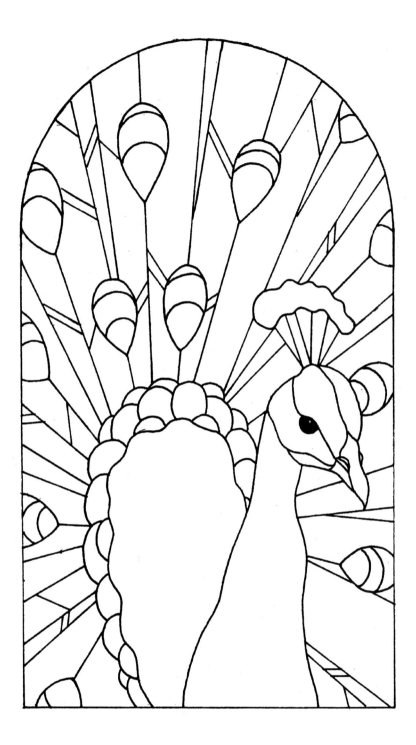

PEACOCKS

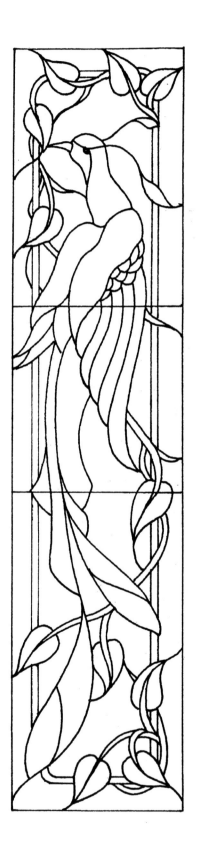

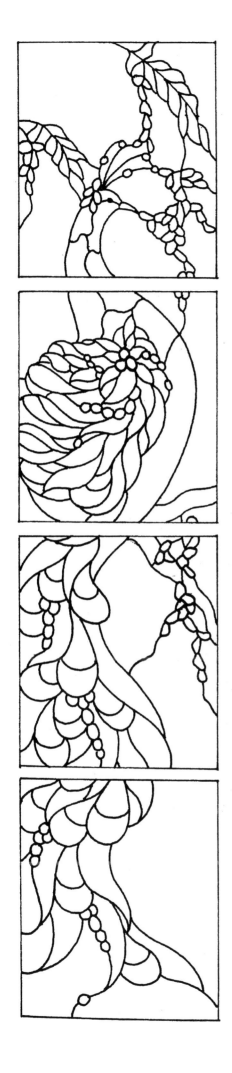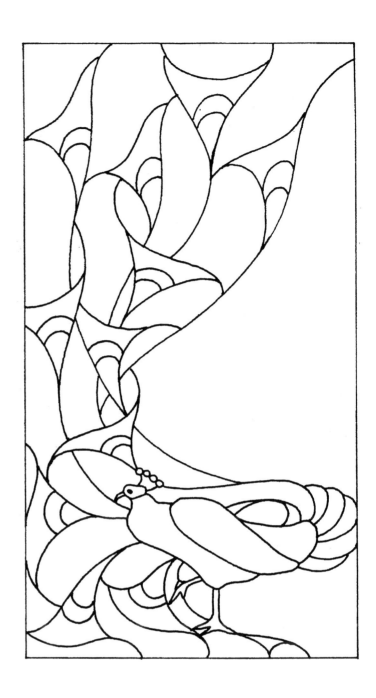

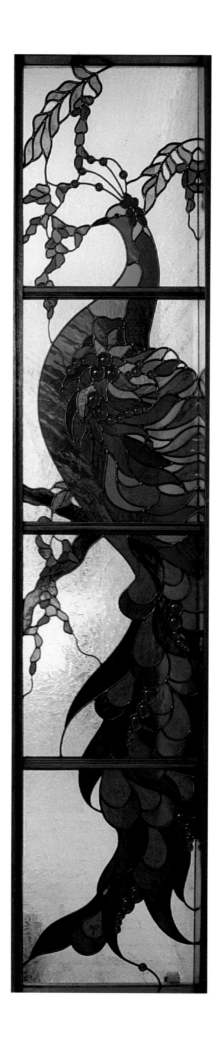

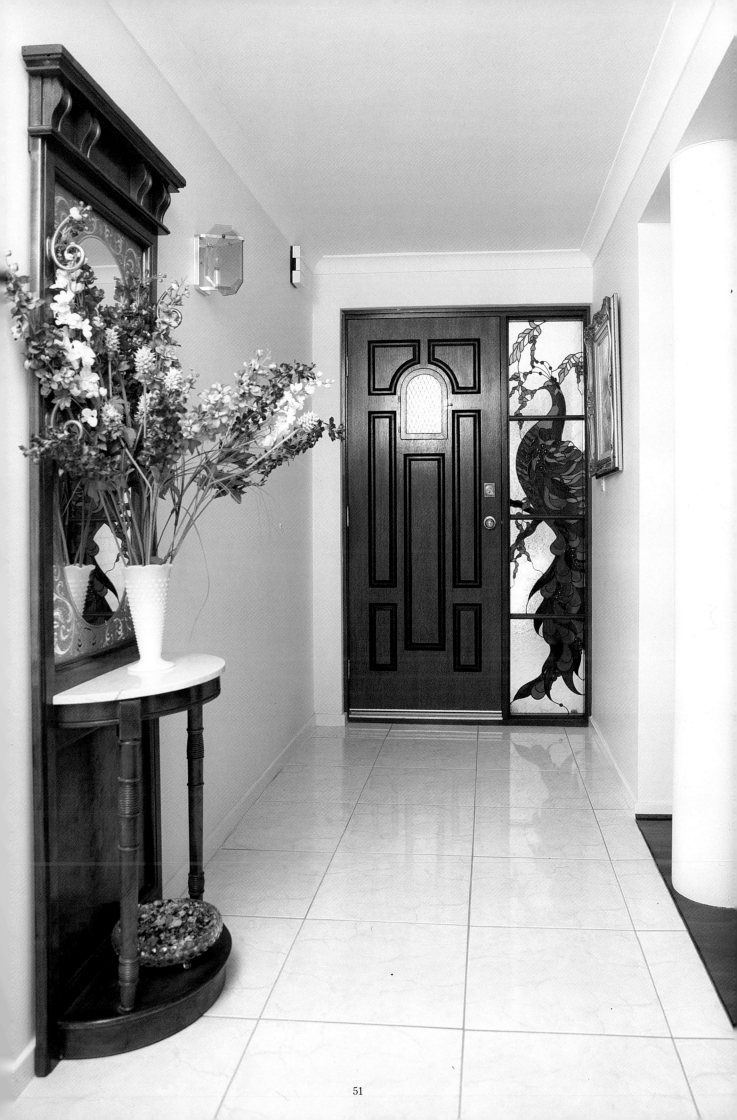

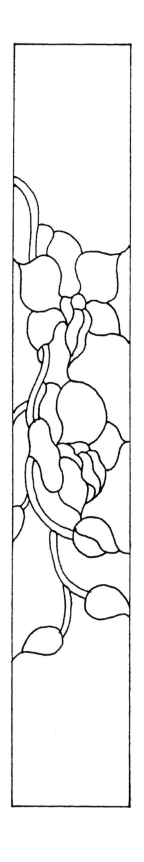

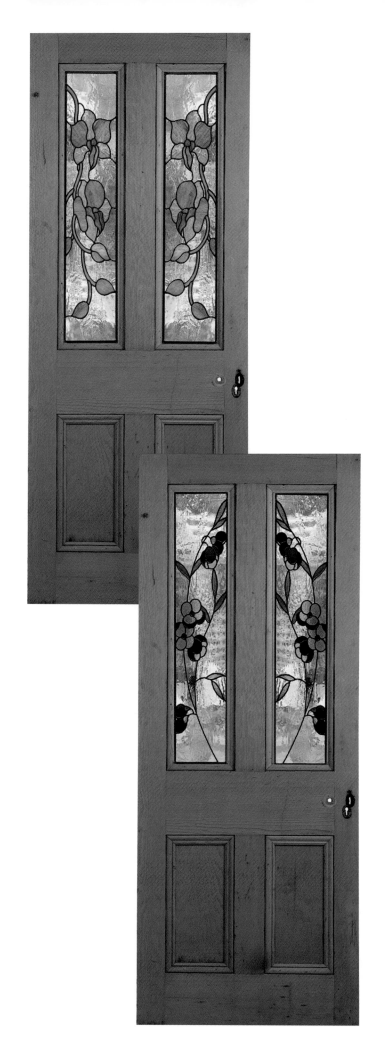

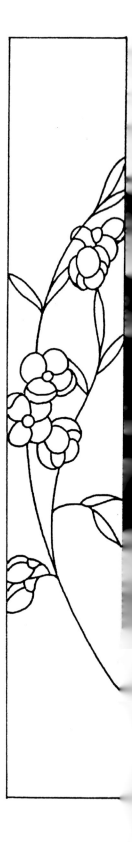

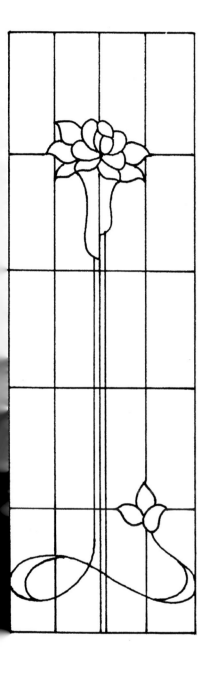

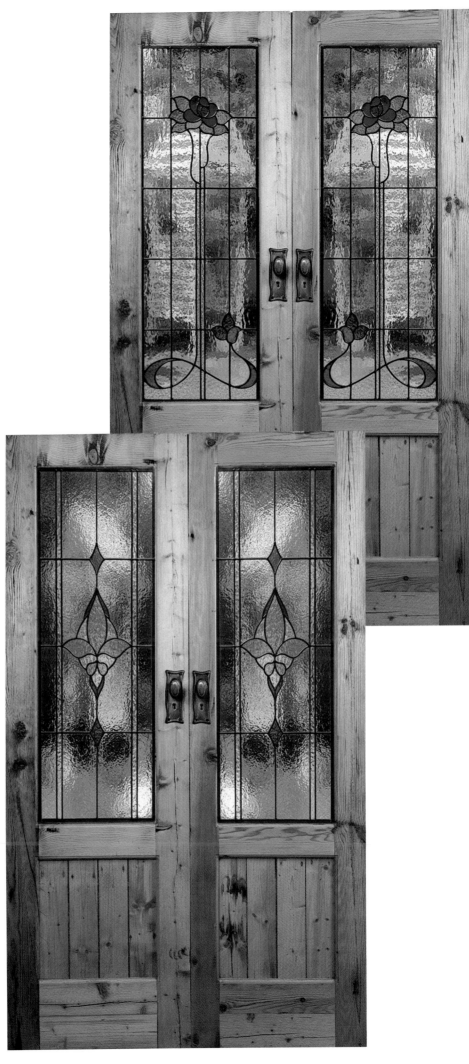

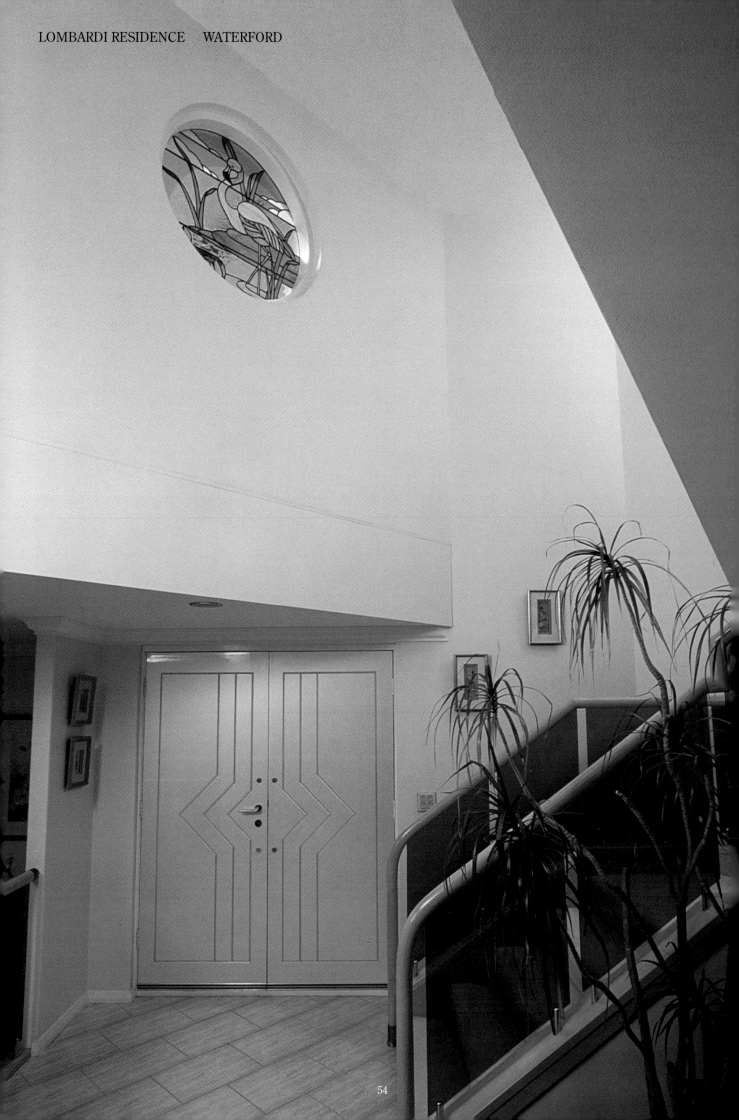

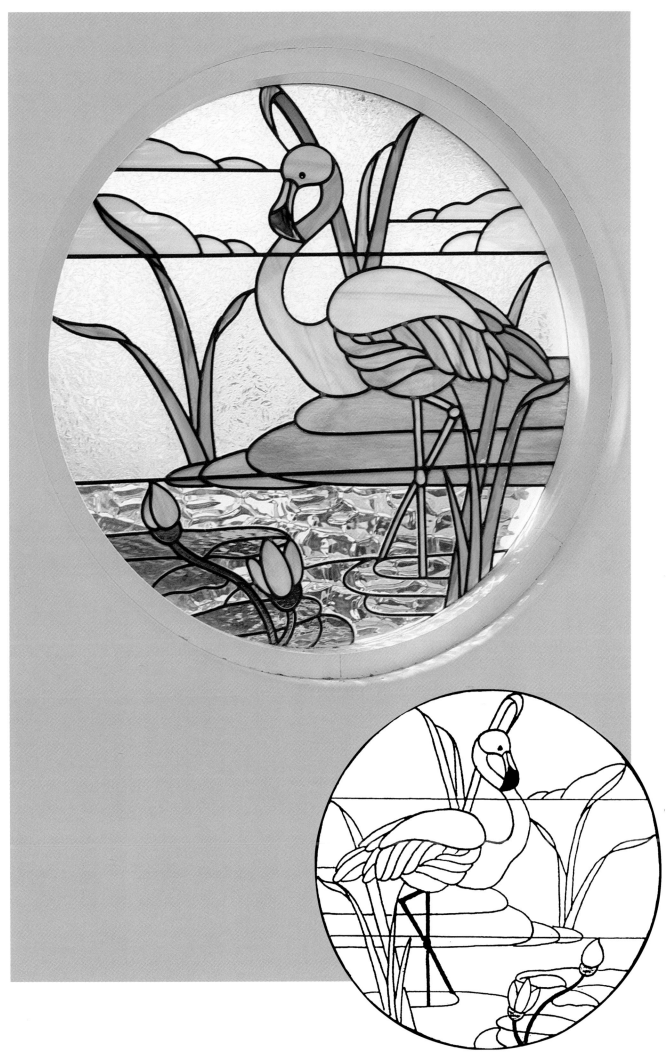

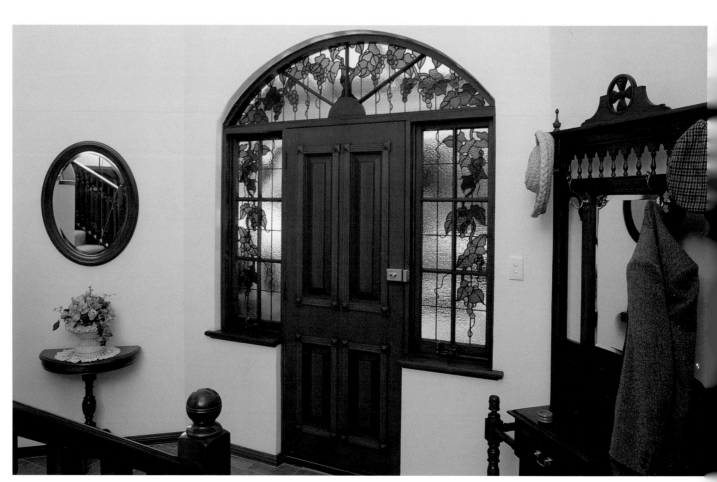

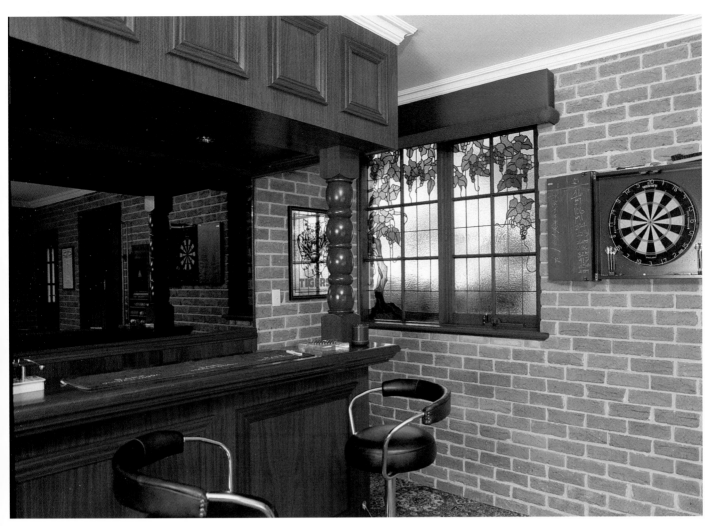

COSSILL RESIDENCE BULLCREEK

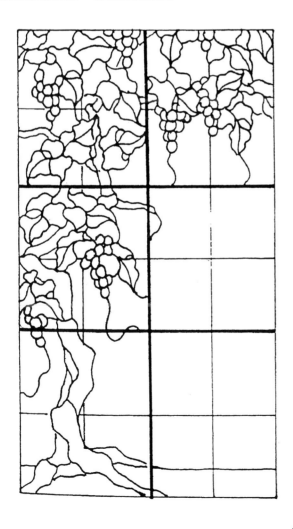
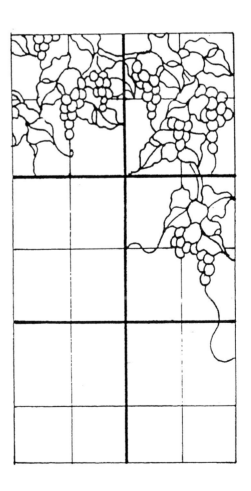

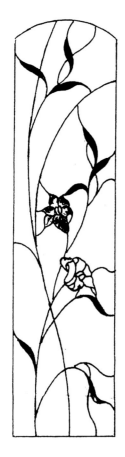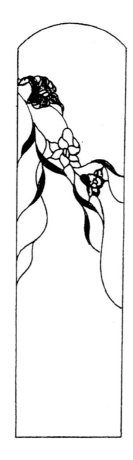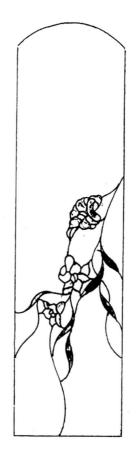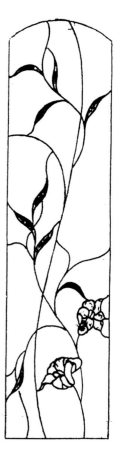

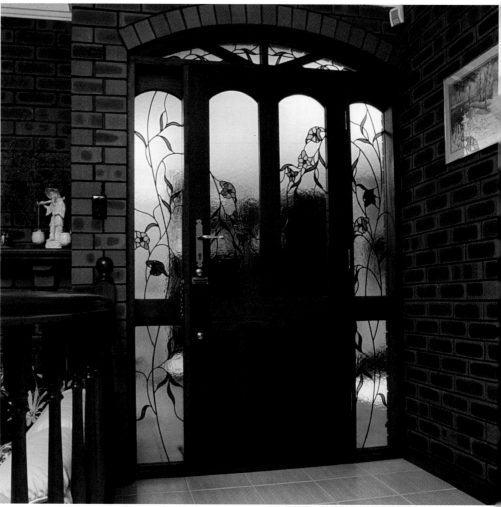

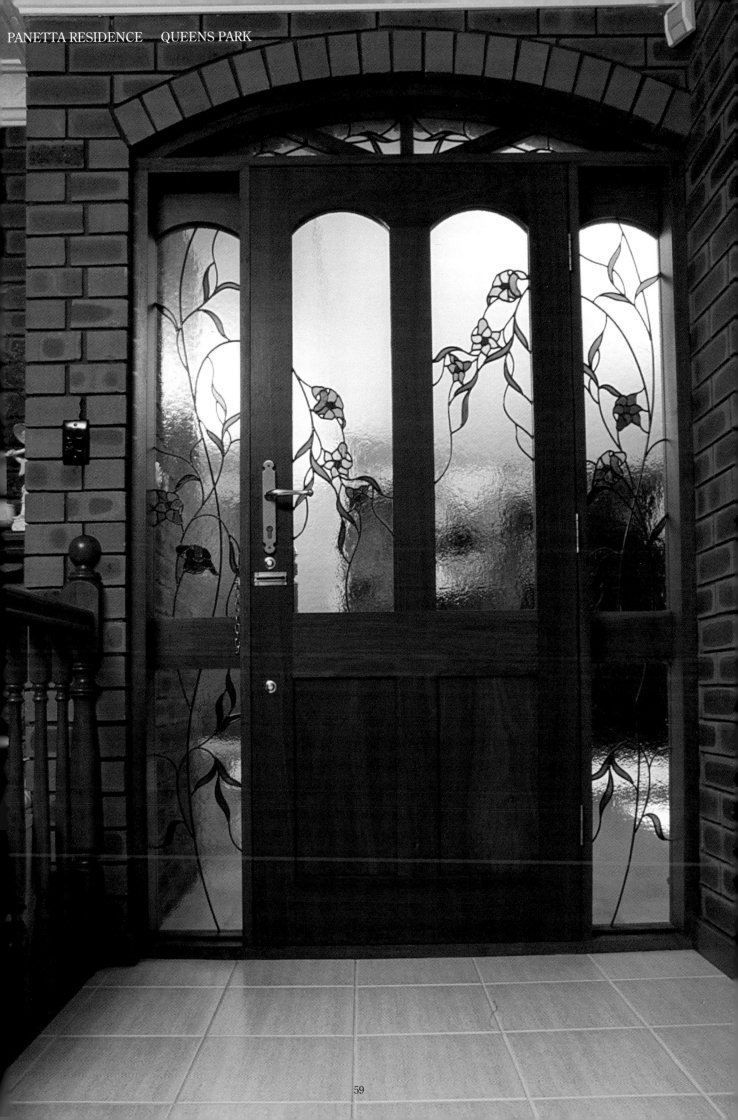

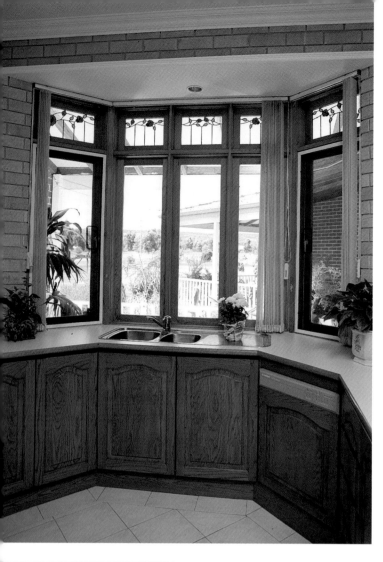

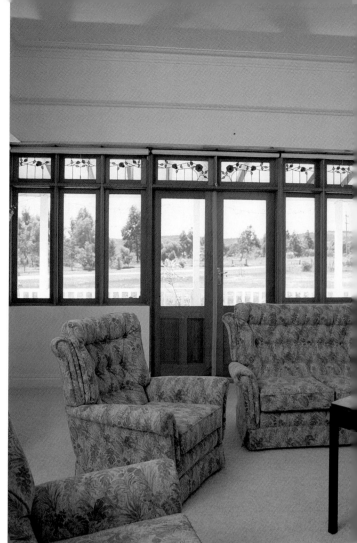

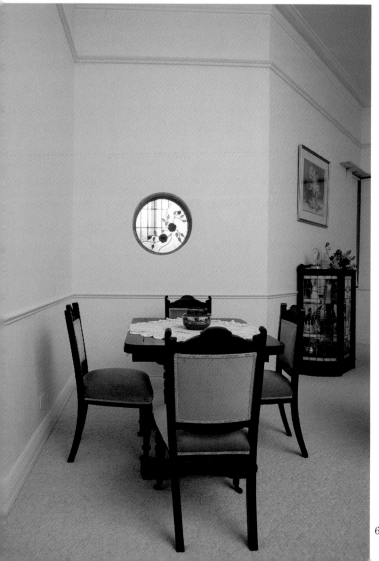

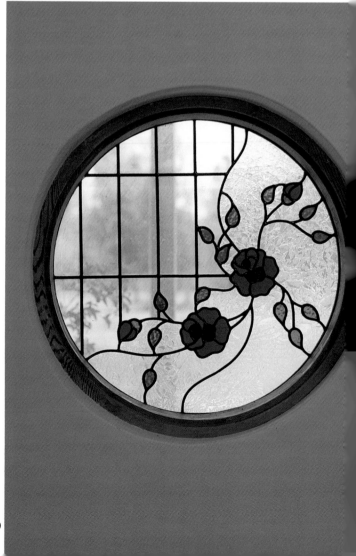

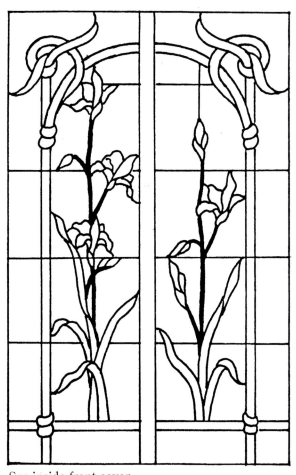

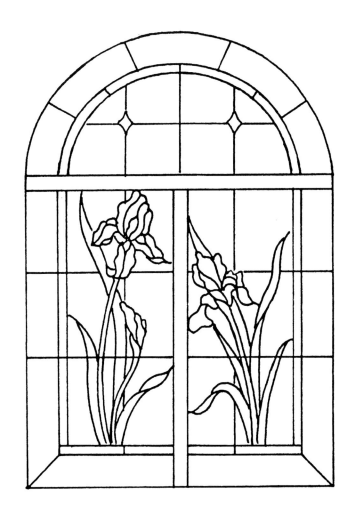

See inside front cover

BIRRELL RESIDENCE BYFORD

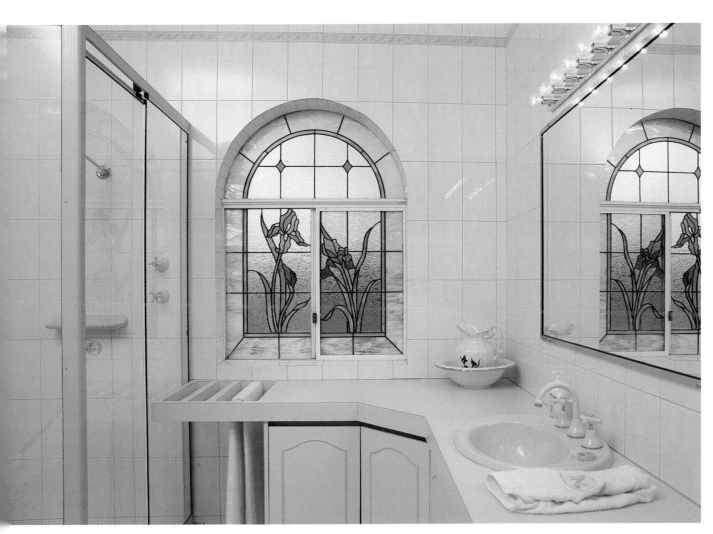

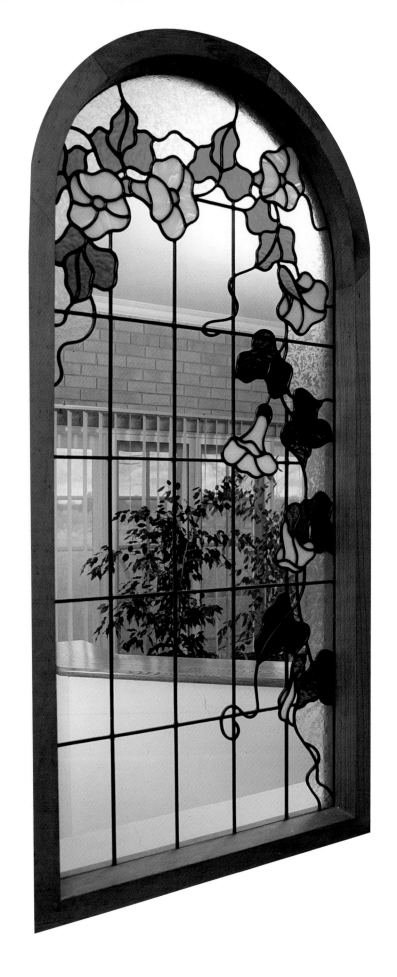

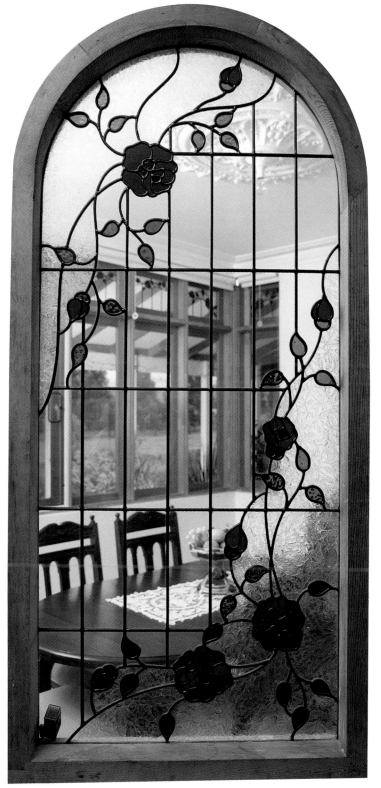

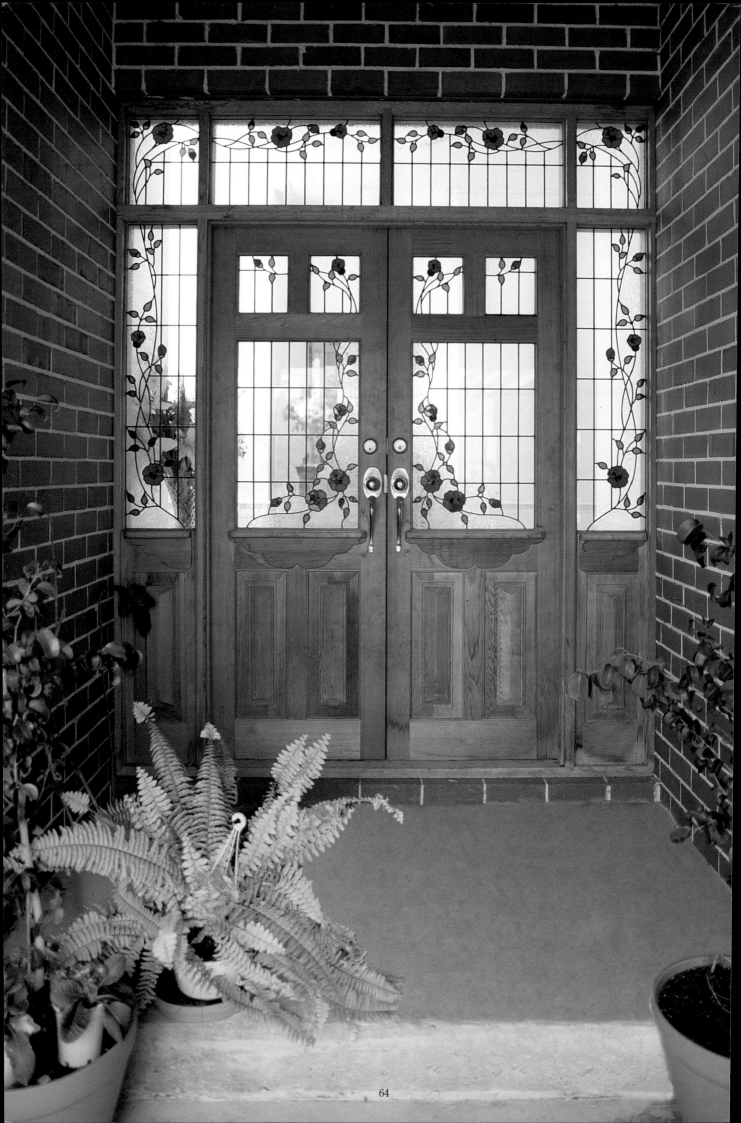